油畫質感表現技法

INTRODUCTION TO

EXPRESSING TEXTURES IN OIL PAINTING

目次

CONTENTS

Translation by Gavin Frew
Layout by AGE.KK

前言

Foreword

　　一旦畫者能使用油彩將物件形狀描繪出來且不會感到太困難，則下一步便是描繪質感。
人們看畫時會説：「這張畫非常仔細，但很可惜，沒有質感。」如果看一張畫作便能一眼看出是何種質料作成的，則畫者已成功地將物件的質感表現出來了。
　　本書告訴我們如何觀察質感，如何表現油彩質感，且以範例解釋並應用各種技法。

Once people have become accustomed to the medium of oil paints and can grasp a shape without too much difficulty, the next problem they find is texture.
People look at their work and say "It has been painted very carefully, but it is a pity that it is lacking in texture." If you can look at a painting and see straight away what the subject was made of, it means that the artist has been successful in grasping the texture.
This book starts by explaining how we look at texture, how this can be expressed through oil paints and finally presents various examples of each technique to show how they can be utilized in practice.

第一章
質感表現的基本技巧

Chapter 1

Basic Techniques to Express Texture

不同的材質要用不同的方法表現

Different Materials Should be Expressed in Different Ways

考慮我們如何區別金屬與木材
Considering How we Differentiate Between Metal and Wood

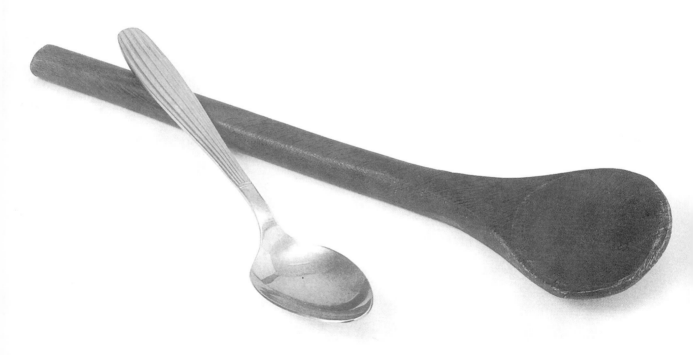

金屬湯匙能有一個細頸而木湯匙卻有較粗的項，而且表面有一層木頭紋理

A metal spoon has a thin neck that cannot be achieved in wood while a wooden spoon is thicker and the surface is covered with the pattern of the grain.

即使在你的畫中，你無法區分出金屬與木質，但如果在視覺上，你無法分別兩者的不同，那就大有問題了。每一個人都有能力區別不同的材質，但是金屬湯匙和木湯匙到底有什麼不同？你如何分辨那個是木質的而另一個是金屬的？只要你開始問這些問題時，你在你畫中表現他們時，已採取了第一步驟。

Even though you may not be able to differentiate between metal and wood in your painting, if you cannot tell the difference visually, you have a problem. Everybody has the ability to differentiate between materials, but what exactly is the difference between a wooden and a metal spoon? How can you tell that one is wood and the other is metal? As soon as you start asking these questions you have taken the first step in expressing them in your pictures.

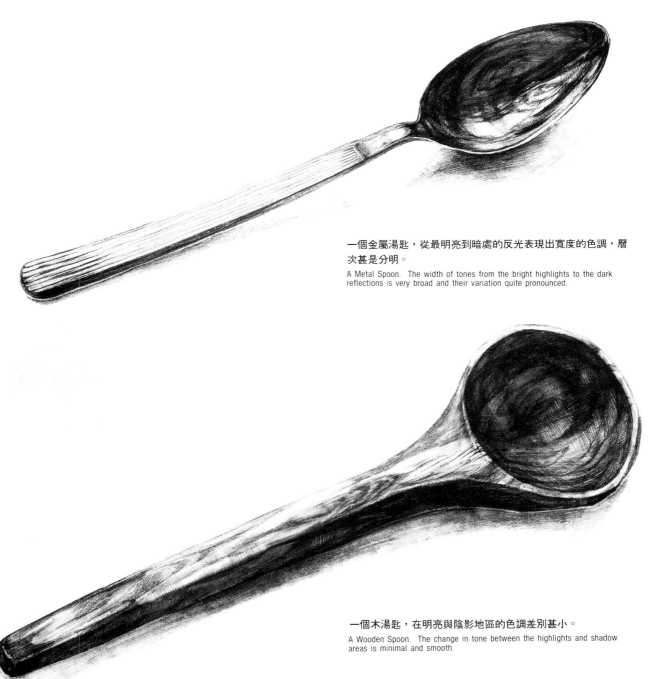

一個金屬湯匙，從最明亮到暗處的反光表現出寬度的色調，層次甚是分明。

A Metal Spoon. The width of tones from the bright highlights to the dark reflections is very broad and their variation quite pronounced.

一個木湯匙，在明亮與陰影地區的色調差別甚小。

A Wooden Spoon. The change in tone between the highlights and shadow areas is minimal and smooth.

由光線和陰影來表現不同的材質

Expressing Different Textures Through Highlights and Shadows

主題材質的不同，陰影的表現也不同

The Shading Varies According to the Material of the Subject

光
Light Source

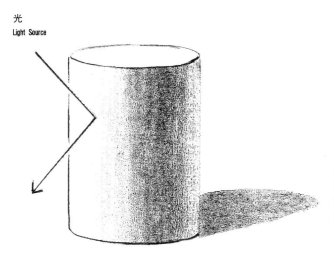

木材、石膏……等，他們會反射光線，並產生強烈的陰影，依據不同的材質，他們會有不同的色彩與質感，但是他們所產生的陰影卻相類似。

Wood, plaster etc. These reflect the light and create strong shadows. They have different colors or texture according to the material but the shadows they produce are of the most basic type.

光
Light Source

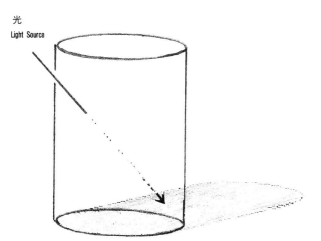

玻璃，光線穿透過物體，所以對物體本身很難產生任何陰影，而投射到桌面的陰影很微弱。

Glass. The light travels through the object so it is very difficult for any shadows to be formed on the object itself and the shadow it throws on the table is very weak.

光
Light Source

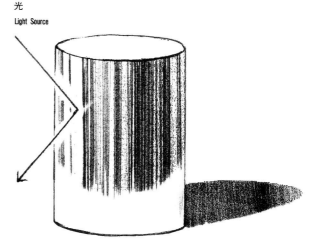

金屬類，整個光線完全被擋到，所以產生非常強烈的陰影，光滑明亮的表面反射週遭的物體，產生非常寬廣的色調。

Metal Objects. The light is blocked completely and a very strong shadow is thrown. The polished surface reflects the surrounding objects and the shading has a very broad width.

照常理來説，一件物品置於光源下，應該有如圖例所示的陰影產生，但是，一個用玻璃製成的物品可使大多數的光線穿透它，所以這種陰影就難以產生。但是，一個金屬的物件在其表面反射出週遭的環境，所以它需要另一種陰影。

As a general rule, an object standing next to the light source should have shading like that shown in the example. However, an object made of glass lets most of the light pass through it so this shading does not occur easily. Again, a polished metal object reflects its surroundings in the surface and so it requires a different kind of shading.

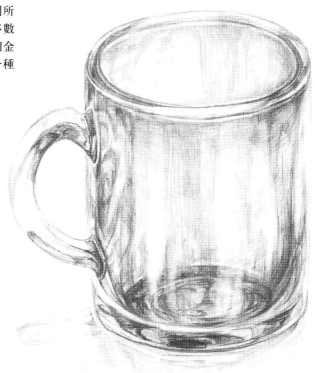

一個玻璃馬克杯，那些說他們能掌握住透明感，但對表現玻璃材質仍有問題的人而言，他們應該注意到玻璃的厚度應該是見的到的，他們包括杯口，杯底以及玻璃厚度是明顯的區域。

A Glass Mug. People who say that they can capture the transparency but still have trouble expressing glass should concentrate on the areas where the thickness of the glass is visible. These are the rim, the base, and the area where the depth of the glass is most apparent - the outline of the sides.

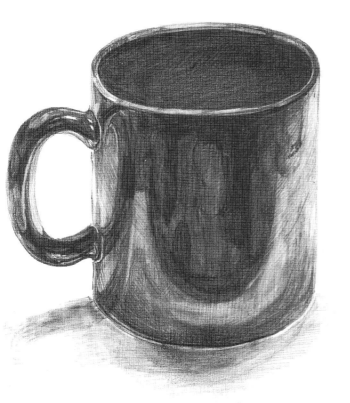

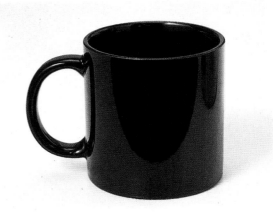

一個黑瓷馬克杯，雖不如金屬那樣反射明顯，但是黑瓷表面也很容易反射週遭環境。像這種情形，用基本的技法很難表現它的形狀，反之它的弧度必須經由桌上被扭曲的反射來表現才行。

A Black China Mug. Although not quite so pronounced as in metal, the dark surface reflects its surroundings quite clearly. In a case like this, it is difficult to express the shape through basic shading techniques, instead the curvature should be expressed through the distorted reflection of the table.

質感的差異表現在輪廓上

Expressing Different Textures Through the Outline

當我們在面前放一個鶏蛋時，我們確知那是一個鶏蛋，因爲這與看到的鶏蛋大小，形狀與顏色相互聯結有關。在日常生活中，我們下意識裡在和我們儲存的資料庫中做種比較，但是當我們畫畫時，我們就必須僅慎觀察，否則我們會發覺，雖然我們明瞭他們的差別，但是在我們的藝術中將無法表現出來。

When we have an chicken egg placed in front of us, we know that it is indeed a chicken egg because it corresponds with the data we possess on an egg's size, shape and color. In everyday life we make these comparisons with our store of data unconsciously, but when painting, we must be deliberate about it or we will find ourselves in the position where we understand the difference but are unable to express it in our art.

試著分析自己的判斷
Analyzing One's Decision Making Process

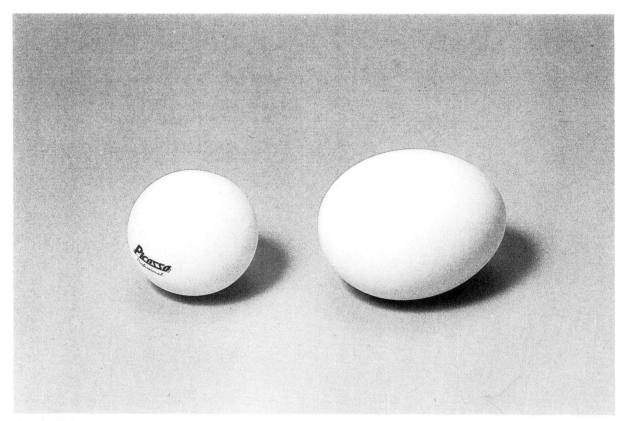

由於造型輪廓的不同，使你可以分別出這個球和鶏蛋來，除非你學會如何精確的掌握住其輪廓外型，否則你永遠無法在你的畫中表現出他們的不同之處。

If it was the shape of the outline that allowed you to distinguish between the egg and a ball, it means that you will never be able to show the difference between them in your drawings until you learn to grasp the outline accurately.

The Hardness of the Material Expressed in the Outline

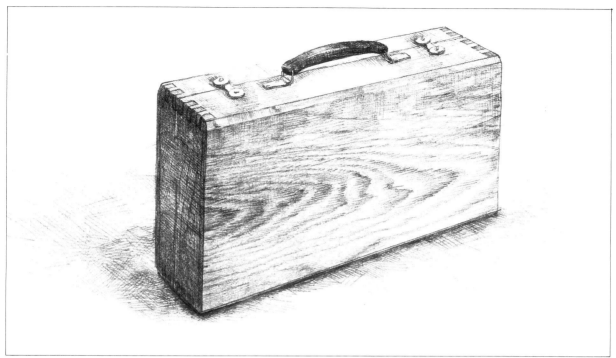

一個木質箱子，輪廓外緣以直挺的線條表現出硬質材料的感覺。

A Wooden Paint Box. The straight lines of the outline produce a feeling of a hard material.

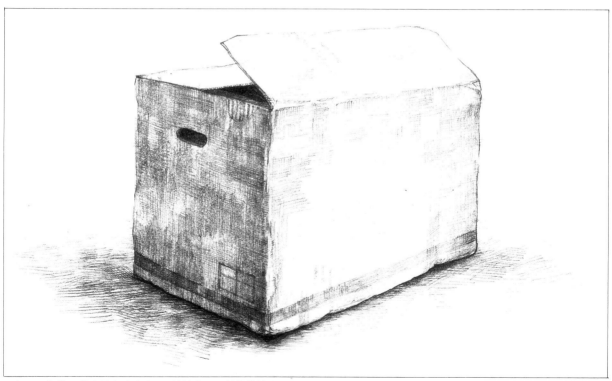

一個硬紙板箱，輪廓線上的波浪狀的線條產生一種軟質材料的感覺。

A Cardboard Box. The undulations in the outline create a feeling of a soft material.

借著強烈反光表現不同的材質

Expressing Different Textures Through Highlights

因物體表面材質的不同，它所產生反光的強度，面積與分佈也因而不同，如在一個明亮金屬球或一個玻璃球體表面上的反光會呈現出一個強烈的光點在中間，使得它和它的週遭環境之間有明顯的邊界線。一個軟質的物件，上面有許多的小孔或是窪陷，則使表面的光線變的分散零碎，使得反光面積變大，而無明顯的邊界線。

A highlight is a strong reflection of light and its size and the way it spreads varies in relation to differences in the surface of the subject. In the case of a shiny metal ball or glass sphere, the highlight is expressed as a small point with a strong borderline between it and its surroundings. With a soft subject, numerous small holes or depressions in the surface lead to the light becoming splintered and diffused, this makes the highlight become larger and have a less clearly defined borderline.

依物件質料之不同，其上所反映之光線亦會有所不同

The Highlight Varies in Relation to the Material of the Subject

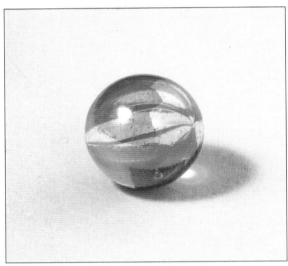

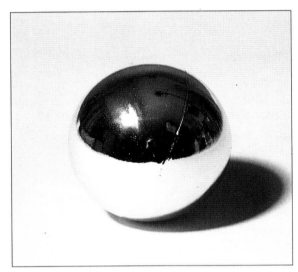

玻璃球
若表面堅硬且光亮，反光便成一小光點。

A glass sphere
When the surface of the sphere is hard and shiny, the highlight becomes a small point.

金屬球
暗色調的天花板映在表面，使反光性增強。

A Metal Sphere
The dark ceiling and surroundings are reflected in the surface making the highlight appear stronger.

在一幅大的畫作中所呈現出的玻璃球體。
A glass sphere that appears as part of a large painting.

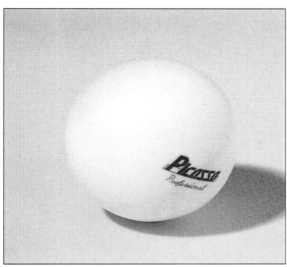

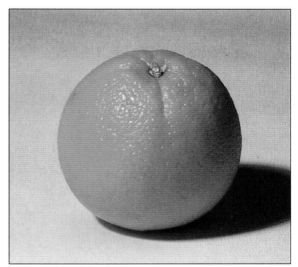
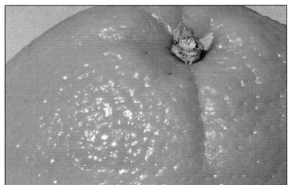

一個乒乓球
將近一半的光線被吸入其中,所以反光很弱,表面上有些許的
層次,使得反光微弱顯現出來。

A Ping-Pong Ball
Approximately half the light is absorbed so the highlight is weak. There are
minute depressions in the surface which make the highlight spread a little.

一個橘子
表現上窪陷的情形使得反光分散零亂

An Orange
The depressions in the surface cause the highlight to break up.

在光線與陰影之間表現不同的材質

Expressing Different Textures
Through the Border Between Light and Shade

光線反射在物件的光亮處,使得難以看見細處,而陰影區也因太暗而無法看清。

而在明與暗之間的邊緣卻是可以清楚的看清細節,而這部份就是應該表達質感的部份。

Light reflects off the bright areas of the subject making the details difficult to see while on the other hand, the shadow areas are too dark to see clearly. The border between the light and dark is the only area where the fine details of the surface can be seen clearly and this is where the texture should be expressed.

如果陰影部份和光源正好是相反方向,會使陰影區看起來更暗。

The stitches of the knitting are visible in the border between the light and shade.

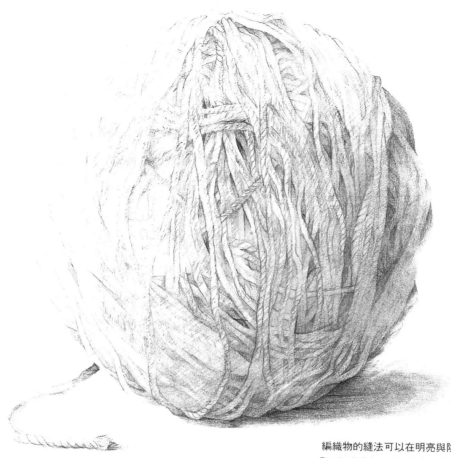

編織物的縫法可以在明亮與陰影之間的區域看見。
The detail of the woolen ball can be seen in the borderline between light and shade.

光
Light Source

毛球的細節可以在光線的明亮區和陰影處之間看見，物體的正面受光部份看起來一樣亮，而不會在凹凸的表面形成陰影光源如果來自其他角度，凹凸面的陰影部份與光亮部份比較起來分外清晰。

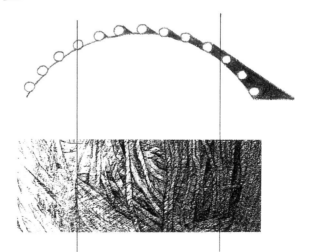

This part looks evenly bright as the light comes from the front and no shadows of the jagged surface drops on.

As the light comes from the angled direction, the shadow of the jagged part and its contrast to the brighter part is very clear.

This part looks darker as it is the shadow area against the light direction.

由反射光的強度來表現金屬的材質

Metallic Texture is

Expressed Through the Strength of the Reflections

依形態不同反射中會產生變化

Reflections Vary According to the Shape of the Subject

　　不鏽鋼或是鉻金屬物件強烈的反射週遭物件和週遭環境，因此，這類物體會有從房間角落的暗處到透過窗子進來的光線，這樣寬度的色調産生。

Stainless steel or chromium-plated metallic objects reflect the surrounding objects and scene strongly. As a result, this kind of subject has a wide range of tones from the dark of the corner of the room to the light coming in through the window.

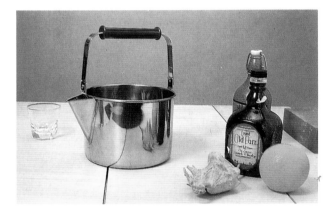

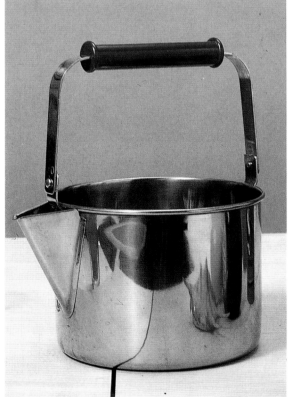

■圓筒形

其附近的物件形狀沒有受到影響

A Cylinder
The surrounding are relatively undistorted.

16

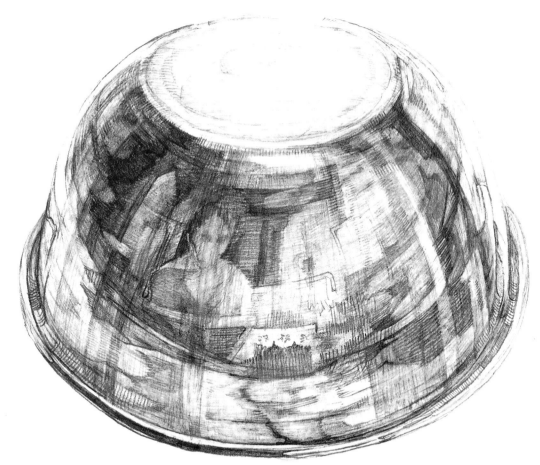

在金屬碗表面反射出畫家的畫作 A reflection of the artist painting appears in the metal bowl

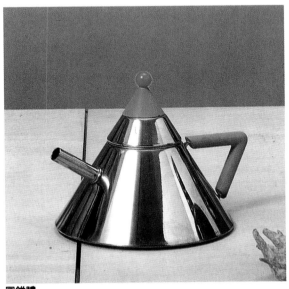

圓錐體

一個高窗子和裡面反射在圓錐壺表面,而非週遭景物。

A Cone
A high window and the walls are reflected rather than the immediate
surroundings.

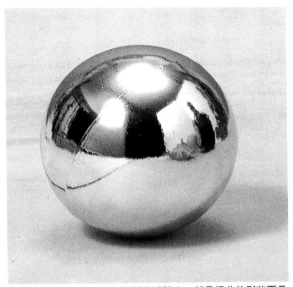

一個球體上下四方全部被反射在球體上,卻是扭曲的形狀而且
看起來很小。

A Sphere
Everything above, below and to both sides, is reflected but is heavily
distorted and appears very small.

經由摺痕來表現衣服的質感

The Texture of Clothes is　Expressed Through the Folds

一件毛衣，經由摺痕的柔軟，弧線來表現材料的柔軟性。

A Sweater. The softness of the material is expressed through the soft, curving lines of the folds.

一件襯衫，它的摺痕和其他衣料比較起來有一種速度感，而集中在下方。

表現衣服質料的祕密在於衣服的摺痕。衣服的厚度與柔軟度可在摺縫間看出來。

The secret in expressing the texture of the material in clothes lies in the folds of the cloth. The thickness of the cloth as well as its hardness or softness can all be seen in the way the folds hang.

A Blouse. The creases have a sense of speed and gather in lower areas than in other fabrics.

一件皮夾克，皮革很厚，所以摺痕之間的空間很寬，然而摺痕的頂端通常很尖銳。

A Leather Jacket. The leather is quite thick so the space between the folds is quite wide, however, the tips of the folds are creased quite sharply.

透過物件背景的顯現來表現玻璃的質感

The Texture of Glass is
Expressed by Showing the Background Through the Subject

當你在畫一個杯子時，你必須顯示出反映在玻璃中的背景。

When you paint a glass, you have to show the background reflected inside.

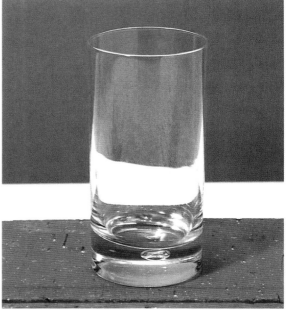

桌緣的線條在玻璃杯中看到的是弧線，當杯子中注滿水時會增加其折射率。

The line of the table can be seen in the glass as a curved line.

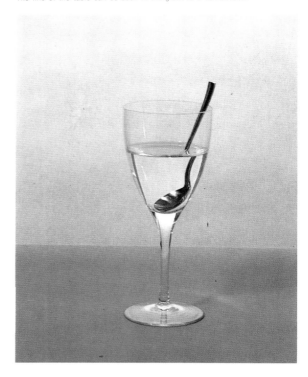

而且湯匙看起來似乎是被切成一半

When the glass is filled with water the refraction increases and the spoon looks as if it is cut in half.

雖然在杯中的反射不如金屬物那樣明顯強烈，但是因爲可透過物件看到其背景，所以色調也很寬廣。有弧度的玻璃物件通常像透鏡一樣可以反射其背景。

Although the reflections in glass are not as strong as those in a metal subject, the background can be seen through the subject and so the range of tones is very wide. Curved glass objects often act as a lens and reflect the background.

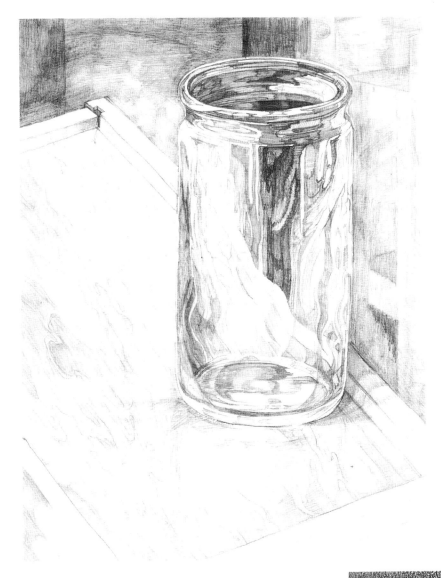

一本書透過玻璃瓶看起來是變形扭曲的。
A book is drawn to look distorted through a glass bottle.

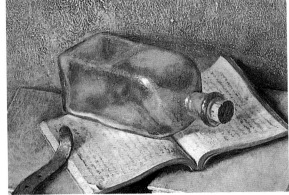

質感表現的相關建議？

Advice on Expressing Texture

如果你瞭解一件物品的材質，但卻無法在油畫中表現出它的質感，那麼請參考下列三個要點：

1.不要讓自己存有任何既有之印象

作畫時最常見的錯誤在於被以前的印象所混淆。「玻璃是透明的，因此我應用白色顏料」，「鐵是灰色的」，「太陽是紅的」，「水是藍的」。如果你的想法存留在此階段，則你的意念將無法接受眼睛所接收且提供的訊息。

2.你看不見的差異，你也將畫不出來

有時你也許知道物件的材質有差異，但卻看不出它們的差異性何在。那張桌子是木紋塑膠材質作成的而非真的木頭作成的桌子，或者你知道罐子裡裝的是鹽而不是糖，但你卻看不出它們之間的不同點。雖然你非常努力的描繪它們的不同，也許最後可以成功，但是大可不必多此一舉。

3.使用正確的工具

你會發覺雖然你可以分辨出材質的不同之處，但是卻無法達到最好的效果。舉例來說，畫一條一公厘粗的線，但所畫出來的卻是一公分粗的線。只有練習對你有用，也許換支刷子也能對你產生幫助，使用正確的工具及適當的技巧能表現出你所希望達成的質感。你所需要知道的技巧均在下一章中介紹。「如果你瞭解其中的不同之處，就能表現它的質感。最重要的是相信你的眼睛。「相信你所看到的」。

If you understand what an object is made of but cannot express it in your painting, think of the following three points.

1. Do Not Allow Yourself Any Preconceived Ideas

The most common mistake is to become confused by preconceived ideas. "Glass is transparent so I should use white paint," "Metal is grey," "The sun is red," "Water is Blue." If you think like this, your mind will not allow you to utilize the information your eyes give you.

2. You Cannot Express Differences You Cannot See

Sometimes you might know that the materials of the subject are different, you cannot see the difference for yourself. You might know that the table is made of wood grained plastic instead of wood or that it is salt in the pot, not sugar, but you cannot necessarily see the difference. Although you may be able to show the difference if you work on it hard enough, in most cases it is not worth the effort.

3. Use the Correct Equipment

Sometimes you may find that although you can see a difference in the subject, you cannot achieve the result you aim for. For instance, you may want to draw a line one millimeter thick but the result is one centimeter thick. Only practice can help you here, but it might help if you were to use a different brush. The use of the correct equipment and techniques are important in order to achieve the expression you desire. Most of the techniques you will require are explained with examples in the following chapter. "If you understand the difference, you can express it." The important thing is your eye, in other words ; "Believe what you see."

第二章
油畫的效果

Chapter 2
Oil Paint Effects

塗上厚層顏料的效果

The Effect of Thick Applications of Paint

　　油畫顏料與水彩顏料相較之下具有厚實的質感。這種厚實的質感可於作畫時來表現畫中圖案的厚實感，或者是牆壁等物件的實體。

Compared to other types of paint such as watercolors, oil paints have tremendous volume of their own and this feeling of mass can be utilized in a picture by laying down a thick coat of color to stress the concreteness of the motif, a wall or some other component of the composition.

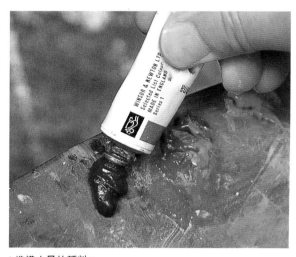

1.準備大量的顏料。

1. Prepare a large quantity of paint.

2.用筆沾起大量的顏料，但不要塗抹在整個畫面，而應將顏料置於畫布上。

2. Pick up a lot of paint on the brush but do not spread it over the picture, rather place it on the canvas.

顏料層次厚的地方可表現所繪物品的厚重質感。

The Area of Thick Paint Accentuates the Existence of the Object Portrayed

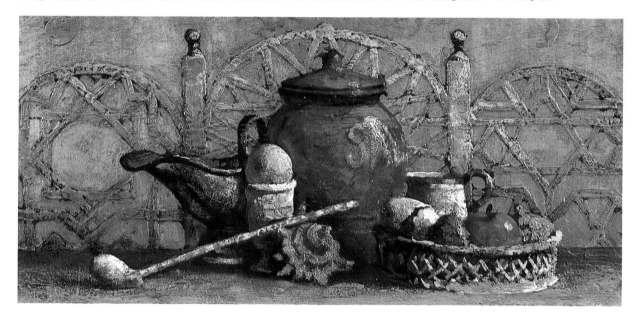

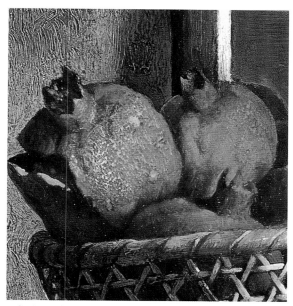

石榴表面粗糙的表皮是由一層層的顏料塗抹晾乾後,再由砂紙摩擦所造成的效果。

The rough surface of the pomegranate's skin is achieved by laying down a thick coat of color then rubbing it down with sandpaper.

厚厚一層的顏料再加上筆刷的刷痕可以表現出牆壁厚實的質感。

The thick coat of paint and the accompanying brush marks express the solid feeling of the wall.

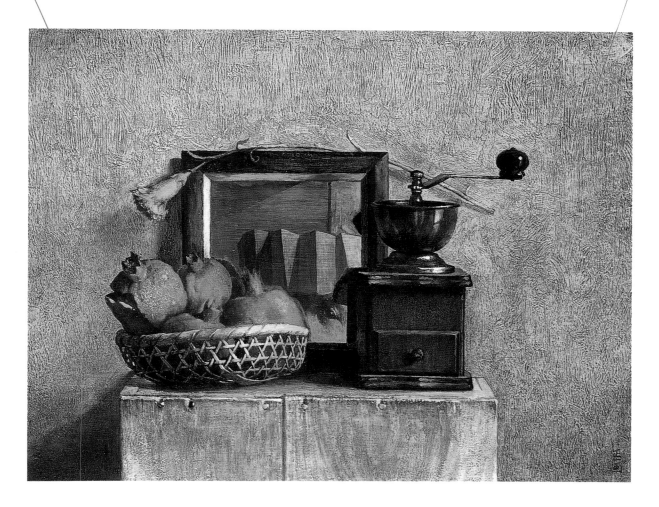

上釉的效果
The Effect of Glazing

上釉是指藉由釉料來稀釋顏料而後作畫，藉以增加亮度及透明度的一種油畫的特殊作畫技巧。

Glazing is a technique in which a color that has been diluted with glazing medium is laid over a prepared surface to achieve a tonality as well as creating a brightness and transparency that is unique to oil paints.

Glazing causes a drop in color value so the lower coat should use brighter colors than usual and it must be allowed to dry completely before applying the glaze.

上釉會降低色彩的明度，所以上底色時要特別注意使用明度高的色彩，以避免掉色，且必須在顏料完全乾燥之後再上釉料。

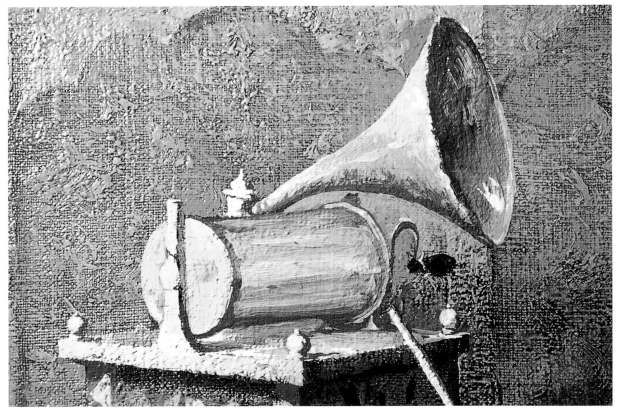

局部圖　　A detail of picture

上釉所使用之色彩
Colors used for Glazing

上釉最好使用透明的顏料，如果使用半透明的顏料，則應在使用前以釉料稀釋。

It is best if transparent paints are used for glazing. If opaque paints are used, they should be diluted with a large quantity of glazing medium before application.

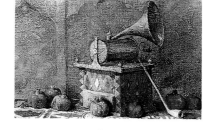

完成圖

The Completed Picture

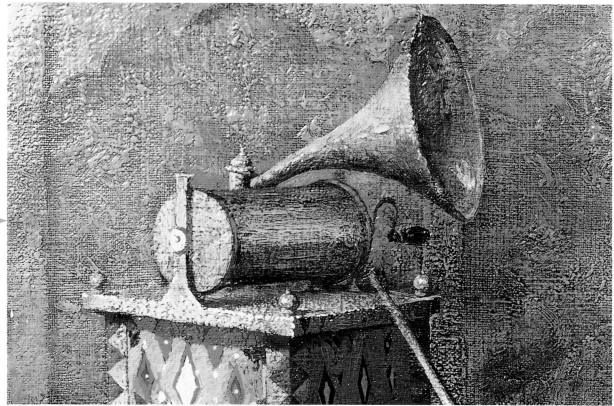

完成圖之局部。藉著塗上一層層的釉料，畫面的色調亦會有所改變。

A detail of the finished picture. By building up repeated coats of glaze, a deep tonality may be achieved.

釉料溶液的準備方法
Preparation of Glazing Agent

一般市面上出售的作畫用油料均可用來稀釋釉料，但必須注意油料的效果及乾燥時間。傳統的釉料溶液大概是最理想的材料，這裡我將介紹使用基本材料及最新材料的技巧。

It is possible to use any of the commercially available painting oils to dilute the paint for glazing, but bearing in mind its effectiveness and speed of drying, traditional glazing agents are probably the best. Here I will explain the techniques involved in mixing both the basic solution and also one using the latest materials.

簡易上釉法

將顏料與果凍狀的釉料溶劑混合。

Simple Glazing Technique

Mix the paint to be used for glazing with the transparent jelly-like medium.

溫格爾（溫莎牛頓公司製造）
Wingel (From Winsor and Newton Ltd.)

將釉料與顏料以1:10的比例混合均勻。
Add the paint to the Wingel at a ratio of approximately 1 : 10 and mix well.

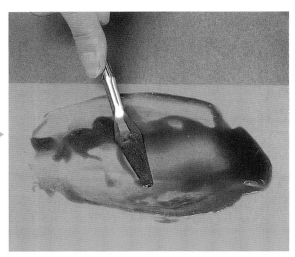

如果稀釋的程度不夠，可用松節油加以稀釋
It may be diluted with turpentine if desired.

如何製造傳統的釉料溶液

How to Make a Traditional Glazing Medium

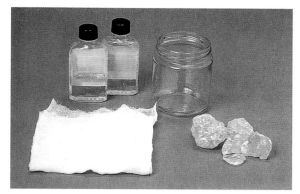

用具及顏料：由左至右分別爲松節油，亞麻油，一個廣口瓶，及樹脂塊。

Materials. From the top left we have turpentine, linseed oil, a wide-topped jar, gauze and damar resin.

如何製造樹脂溶液
樹脂溶液稀釋後可用來上光。而亞麻油可用於稀釋油料。

　　這項材料在釉料的製作上是很重要的，可稱爲油畫的「生命之水」。已調好的釉料可在美術用品店買到。雖然調好的釉料溶劑也可使用，但我們還是來看看如何自己製作所需的釉料溶劑。

How to Prepare a Solution of Damar Resin

Damar can be diluted to create a varnish or a large amount of linseed oil can be added to produce a thinning oil. Of course it plays a major role in producing glazing medium and could be called the "Water of Life" of oil paints. Commercially prepared damar varnish is available from all the major suppliers, and while this is adequate for our need, let us take the time here to produce our own.

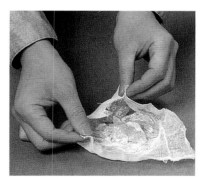

1.剝碎的樹脂塊以紗布包起來。

1. Break up some Damar resin and wrap it in the gauze.

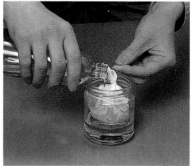

2.將之吊在廣口瓶上，倒入松節油。（每一百公克的樹脂塊約加入200至300公克松節油）

2. Suspend it inside the jar and pour in the turpentine. (Use approximately 200-300 grams of turpentine per 100 grams of Damar resin)

3.樹脂塊應在二十四小時之內即可溶解。紗在塊內的殘留物應予丟棄。

3. The Damar should dissolve in approximately twenty-four hours and the impurities that are left in the gauze should be disposed of.

如何製造溶劑

亞麻油　1

樹脂溶液　1

松節油　1

將上列三種溶劑混合則可得釉料溶劑

How to Prepare Glazing Medium

Linseed Oil　　　1
Damar Varnish　 1
Turpentine　　　2
Mix the above ingredients to create the glazing medium

用帆布作畫的效果
The Effect of the Canvas

選擇畫布

　　畫布有粗質及細質的畫布，而它們的質感在作畫時可以加以利用。畫作完成後的畫面質感受畫布質地影響甚大。畫布上的凸起處和凹陷處經光學作用後可發揮非凡的調色作用，甚至更甚於作畫前所調配的顏料效果。

Canvases come in both rough and fine textures and this texture should be utilized when painting. The surface texture of the finished painting is greatly influenced by the texture of the canvas chosen. The texture of the canvas can be used so that the color in the depressions mixes optically with that on the protrusions to create a hue with a higher saturation than can be achieved by mixing the paints physically before application.

市面上出售的畫布
Commercially available canvases

細質畫布－原尺寸大小。

Fine Texture - actual size.

粗質畫布－原尺寸大小。

Rough Texture - actual size

自製畫布－原尺寸大小。
這是從店裡所選購的極粗麻布在塗上油料而成。

A home-made canvas - actual size. This is a very rough linen material which was bought from a textile shop then coated with Gesso.

粗質畫布。如果顏料是以乾的筆刷輕塗於畫布之上，則可製造出
點狀的作畫效果，並加強畫面的色調變化。

A rough canvas. If the paint is applied lightly using the drybrush technique
to produce a broken coat similar to pointillism it will add depth to the tonal
variety.

畫布的效果

畫布的效果可作爲表現物件質感的方法，因爲其本身即爲
布料，則可用來凸顯布的質感。

The Effect of the Canvas Texture

The texture of the canvas can be utilized is some
areas and hidden within others to help express the
texture of the subject. For instance, being a
material itself, it is useful when expressing the
texture of cloth.

1.使用乾的畫筆將顏料塗抹於畫布上凸
起的粒子。

1. Create a base surface using drybrush
technique to apply the paint only to the
raised threads of the canvas.

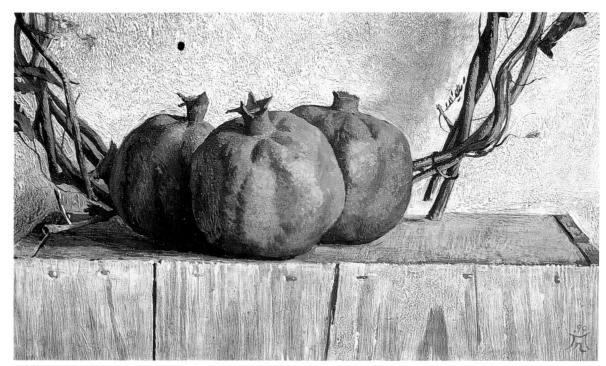

2.木箱的顏色經由釉料的渲染及畫布下凹粒子所造成的效果而看
起來有木頭的質感。

2. The color of the box which is applied using glazing technique accumulates
in the depressions of the canvas and creates the texture of a roughly
finished wooden board.

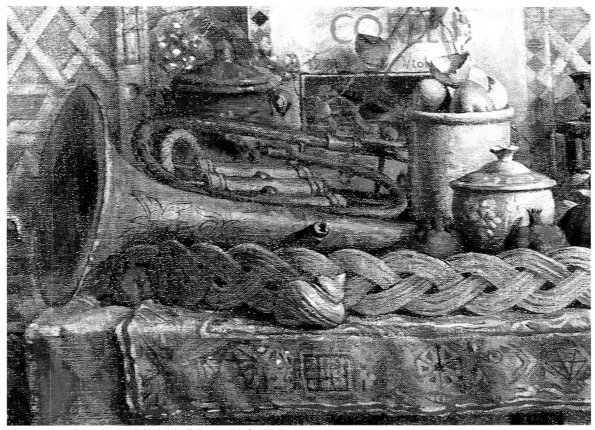

爲表現喇叭光滑的表面以及背景磁磚的質感，必須在畫中塗上
極厚的顏料，使其與畫中其它物件形成強烈對比。
而畫布則用來表現桌中的質感。

A thick coat of paint is used to hide the texture of the canvas when
expressing the shiny surface of the trumpet and the pattern on the tiles in
the background, creating a strong contrast with the rest of the subject.
The texture of the canvas is utilized to express the texture of the table cloth
in the foreground.

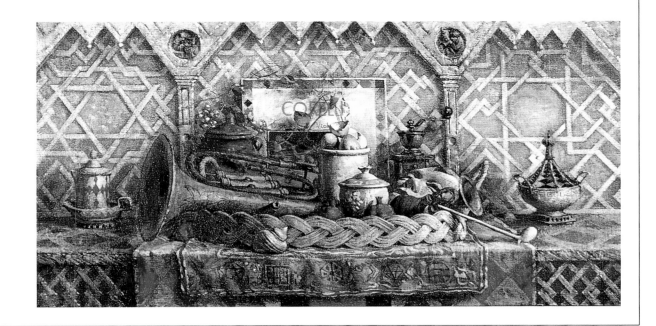

底色的效果
The Effect of a Toned Ground

要在白色的畫布上製造色調的變化頗爲困難。先上一層底色有助於在上其他色調時調和顏色。用底色作爲基礎，然後再將顏料由淺至深上色以達到所需效果。而效果最好的底色是中性色調。

It is difficult to recreate the tonal changes of the subject accurately on a white canvas. It is much easier if a ground color is first applied over the entire canvas then the other tones built up over this. Using the ground color as a base, gradually add the lighter and darker tones to create the desired result. The best results are achieved if a mid-tone is used for the ground color.

底色的樣本範例：
Samples of toned ground colors

1.將淺紅色塗上作爲底色

1. Apply light red as the ground color.

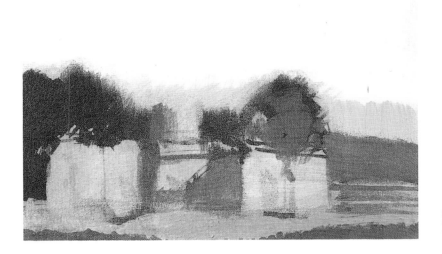

2.使用底色作背景，上深色作爲樹，淺色爲建築物的牆壁。

2. Using the ground color as a base, add the darker tones of the trees and the lighter tones of the building's walls.

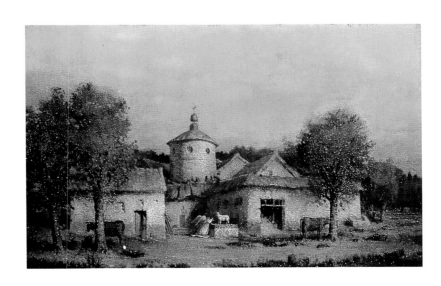

3.完成圖

3. The finished result.

畫「籃中靜物」之方法
Painting a "Basket Still Life"

將正確的形狀描繪出來　　Draw the Shape Accurately

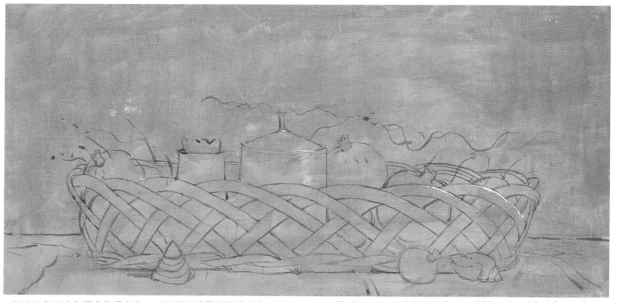

1.將淺紅色與白色混合作為底色。然後用力將圖形描繪上去，使
用稀釋過的象牙黑來描線。炭筆會使顏料無法附著在畫布上，
應避免使用。

1. Mix light red and white to produce a mid-tone ground then draw in the shape strongly, using well-diluted Ivory Black. Charcoal prevents the paints from binding to the paper properly so it should be avoided.

將光源部份標出
Pick out the Highlights

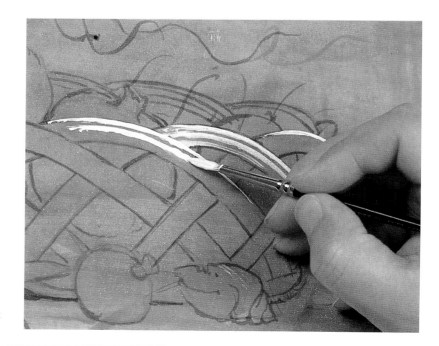

2.在確認光源方向後，將籃子的邊緣以
白線標出。

2. After ascertaining the direction of the light, pick out the weaving of the basketwork using white.

在本章中介紹了許多實用的技巧。此處我們只使用兩種,即上釉及挑出描白。

Many useful techniques have been introduced in this chapter and here we are going to concentrate on two of the most effective, Glazing and Picking-Out, to see how they can be used in a painting.

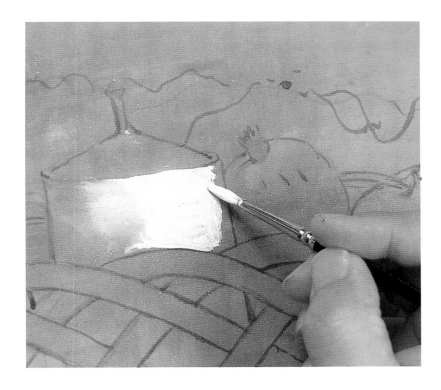

3.挑出罐子光亮的部份,以處理籃子邊緣的相同方式處理。使用大量白色顏料及一點點原物件顏色之顏料。這些顏色的彩度應非常地高,才足以使上釉的程序發生效果。

3. Pick out the light areas of the jugs in the same way that you did for the basket. When doing this, use white and mix in just a hint of the actual color of the subject. These highlights should be made almost too bright in order for the glazing to be effective.

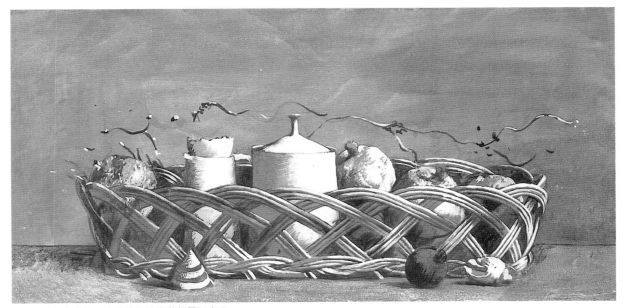

4.光源部份完成後,上釉前的準備動作便已完成。

4. Once the highlights have been added, preparations for the glazing are complete.

第一次上光　　　The First Glaze

將少許褐粉紅顏料與釉料溶液調和稀釋。

Dilute some Brown Pink in glazing medium.

將顏料及溶液以1:10的比例調勻以防止上色不均。

Dilute the paint and glazing medium at a ration of 1:10 and mix thoroughly to prevent any unevenness.

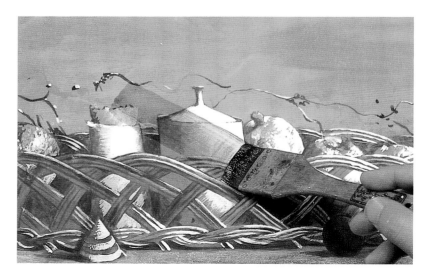

5.使用寬畫刷將溶劑均勻塗抹於整個畫面。

5. Use a wide brush to apply the glaze over the whole canvas.

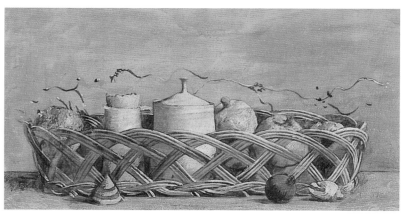

6.第一次上光之後的作品。

6. The picture after the first glaze has been applied.

一次次地反覆上色及上釉
Build Up the Highlights and Glazes Repeatedly

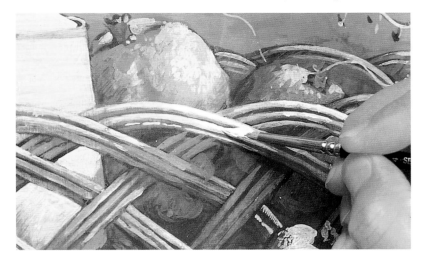

7.在籃子的色調變暗後，再次描白，等其乾燥。

7. After the basketwork has been darkened by the first glaze, pick it out with white again and allow to dry.

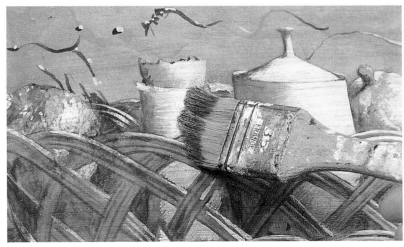

8.再上一層釉以乾刷抹勻以防止畫面產生不均。

8. Apply another coat of glaze then go over it again with a dry brush to ensure that there is no unevenness.

9.若用手掌上釉，則釉料將被拍打至畫布凹下粒子上而產生畫面亮度減低之效果。

9. If the glaze is spread with the palm of the hand it will push the glaze down into the depressions of the texture of the canvas and produce a darker result than a dry brush.

加強物件之色彩　　Build Up with the Color of the Subject

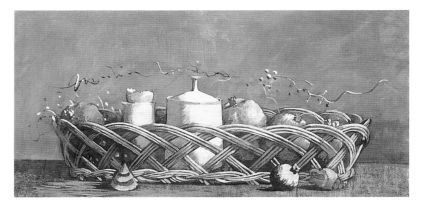

10.第二次上釉後之作品。

10. The result after the second glaze has been applied.

11.將石榴及藤枝的顏色加重,然後加強表現各物件之質感。

11. Add the color of the pomegranate and vine then create the expression of the surface of each object.

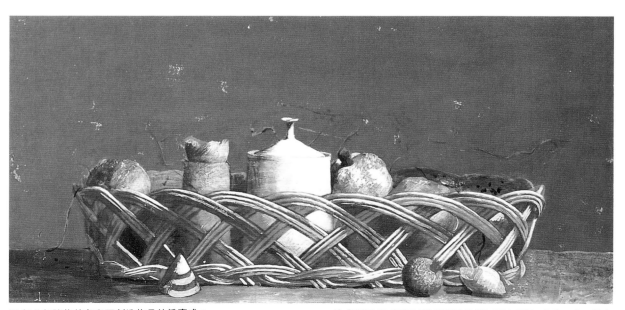

12.如此加強物件色彩可創造物品的真實感。

12. Building up glazing and coloring in this way creates a feeling of reality in the subject.

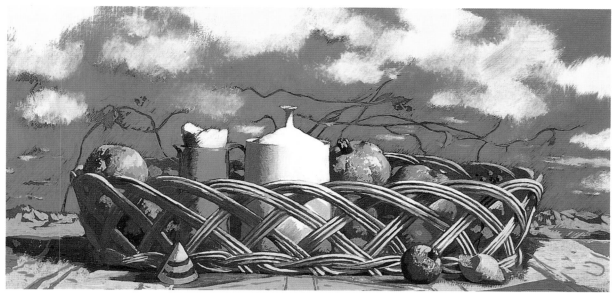

13.在背景上加強以描繪天空。

13. Add a background that hints at the sky.

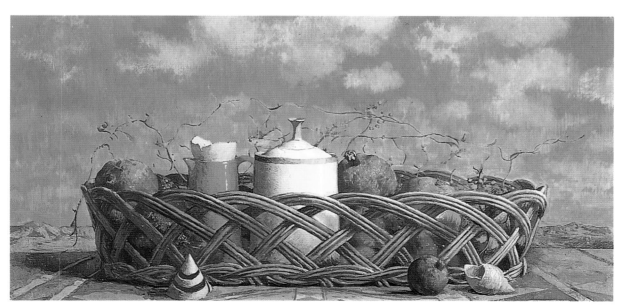

完成圖　　　The finished result

上釉之建議
Advice On Glazing

　　從本章的「籃中靜物」範例中應可看出當作畫時，許多技法可用來加強色調。為表現在所看到及所察覺到的物品質感，作畫時應先決定是否須使用透明或不透明之顏料，要用多少顏料以及顏料是否應予以混合。上釉可說是油畫中的代表性技法，且非常有效。很多人認為上釉是萬靈丹，而在他們的作品上廣泛的應用，但以下是應注意之事項。

上釉之要點：

1.唯有在顏料厚重，色調明亮且完全乾透的畫面上釉才有效果。

2.等到釉料溶劑乾透之後再描繪物件的形狀，除非這些步驟已重覆數次，否則畫面將顯得薄弱。

3.上光時每一層越薄越好，不要一次上一層很厚的釉。

以免畫面容易龜裂，且產生無法與其它物件協調的光澤。

As you can see from the section on the "Basket Still Life" in this chapter, when oil painting one uses numerous techniques to lay down multiple coats of color. In order to express what one sees and feels in the subject one has to choose whether to use transparent or opaque paints, how much volume to apply and whether they should be blurred. Glazing could be said to be representative of oil painting techniques and as you can see, it can be very effective. A lot of people think of glazing as some kind of magic panacea and use it for all their work but the following points should always be borne in mind.

Points When Glazing

1. Glazing has little effect unless it is laid over bright paints which have volume and have been allowed to dry completely.
2. Wait for the glazing to dry then go over it again to pick out the shape of the subject. Unless these steps are repeated numerous times the picture will appear rather weak.
3. Make each coat of glaze as thin as possible, do not try to apply a thick coat in one application. Not only is a thick coating of glaze liable to crack but it may also produce a luster which will not harmonize with the surrounding colors.

第三章
表現方法

Chapter 3
Methods of Expression

銅壺及水果
A Copper Pot and Fruit

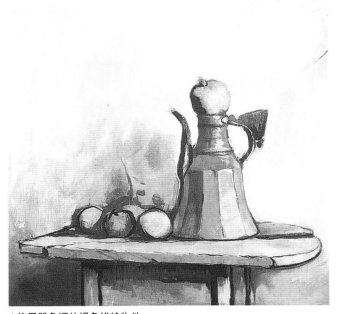

1.使用單色調的褐色描繪物件
1. Express the shape using a brown monotone.

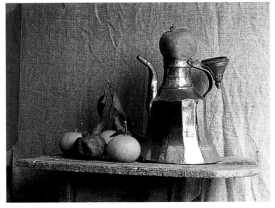

原始照片
A photograph of the subject

2.使用明度高之色彩描繪物件。
2. Color the subjects with bright tones.

三件物品的質感各自形成對比。金屬的堅硬與水果的新鮮形成對比，而木桌的脆弱及暖調更強調了金屬的冷硬。讓各種不同質感的東西形成對比是很重要的，否則你將會受限於作畫的二度空間畫面上。

Each of the three different textures in the subject produce a contrast which accentuate the other textures in the picture. The hard texture of the metal serves to accentuate the freshness of the fruit while the fragility and warmth of the wooden table brings out the coldness of the metal. It is important to contrast different types of texture in a picture in this way or you will find yourself unnecessarily limited in what you can express in this two dimensional medium.

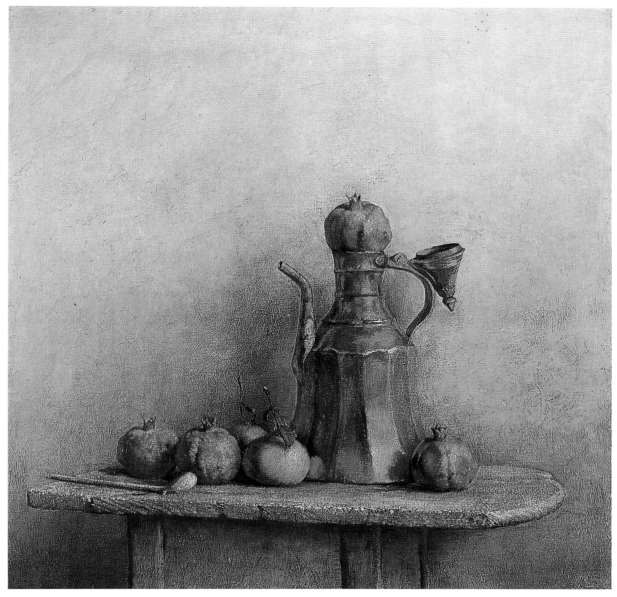

参考作品　　　The reference work for the steps described here.

果實的描繪

　　有特徵的水果表皮是經由反覆的點狀畫法及上光達成柑橘類果皮凹凸不平的效果。果皮上的凸粒在光源部份及邊緣特別明顯。但如果將這種質感整個表現出來，則會造成反面效果而使水果失去真實感。

Expressing Fruit

The characteristic dimpled skin of citrus fruit is expresed through repeated pointillism and glazing. The highlight of the dimple is particularly pronounced in the highlight area and on the border between the light and dark areas. However, if this texture is applied in detail over the entire surface of the fruit, it will have a negative effect and the picture will lose its feeling of reality.

1.將整個畫面之明暗以同色調顏料標出。
1. Grasp the main areas of light and shade using a monotone.

2.使用鎘黃色加強亮部的細節。
2. Using Cadmium Yellow, start to add the details in the bright areas.

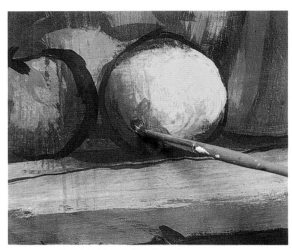

3.在細部以濃黃色加強，待其完全乾透。
3. Add the detail to the shadow areas using Raw Sienna and allow to dry completely.

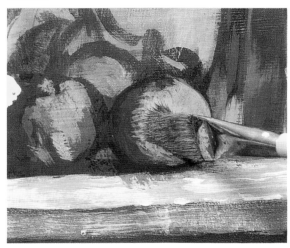

4.上一層褐粉紅的釉色。
4. Apply a glaze of Brown Pink.

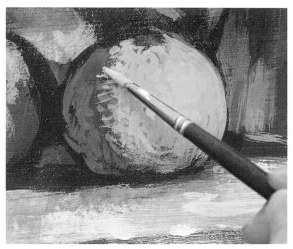

5.使用橙色再次描繪水果本身。可在邊緣加深筆劃，另外明處及暗處各自加強，表現水果的質感。

5.Pick out the shape of the oranges again using a bright color that matches that of the fruit itself. Build up the strokes on the borderline between light and dark to produce the texture of the surface of the fruit.

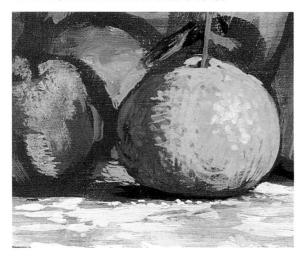

6.為表現表皮的質感，使用畫筆的筆尖點畫。

6. In order to express the texture of the skin, use the tip of the brush to apply highlights through pointillism.

7.顏料完全乾透後，再上一層釉。

7. Once the paint has thoroughly dried, add another coat of glaze.

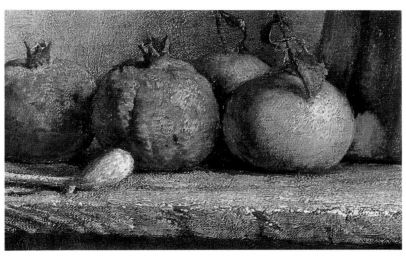

作品完成圖。

A detail of the reference work.

銅壺的描繪

銅壺的描繪要點在於銅壺下部下凹部份與上半部的圓弧形成對比。在畫底部時，下凹部各種不同的色調必須小心處理，才能形成畫面所需之深度。而相對地，上半部的描繪則需注意設計上的柔軟弧度及纖細程度。這兩種對比是作畫時所需注意的要點。

Expressing the Copper Pot

The characteristics of this pot lie in the fluted sides of the base, contrasted with the roundness of the neck and spout. When painting the base, care must be taken to show the different tones of each surface of the fluting in order to express the depth of the subject. By comparison, the upper half should concentrate on the soft curves and fragility of the design. It is this contrast of the two sections that you should focus on when working on this subject.

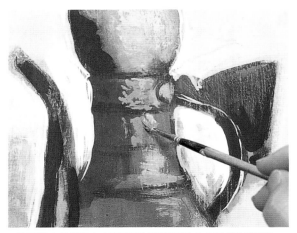

2.使用較亮的顏色來表現壺頸的弧度以及其上突起的環狀物。

2. Use a brightish color to express the curve of the neck and the rings that stand out from it.

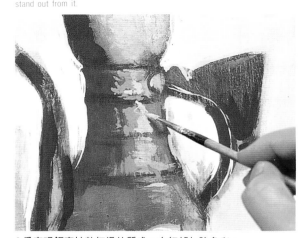

3.為表現銅壺被敲打過的質感，在細部加強色彩。

3. Add the highlights showing the slight depressions created when the pot was beaten out.

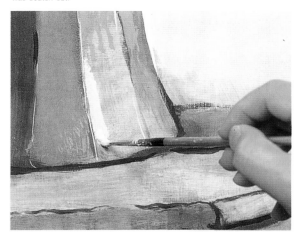

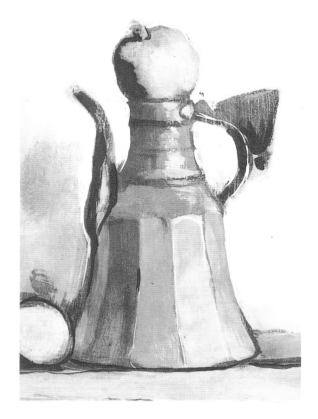

1.使用單一色調表現水壺的深度。牆壁的畫法可決定壺的生動程度。

1. Use a monotone to express the feeling of depth in the pot. The way that the wall in the background is painted will ensure that the outline does not become boring.

4.在需表現金屬的硬度及光滑程度之處用較亮的色彩加強。

4. Use a bright color to pick out the areas which show the strength and smoothness of the metal.

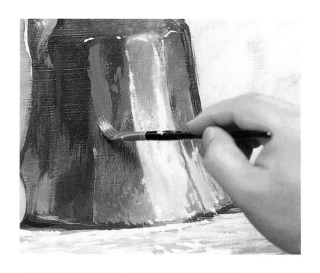

5.畫此類物品的重點之一是需在陰影部份加上反光。

5. One of the points to watch when approaching a subject like this is to add the reflected light within the shadow areas.

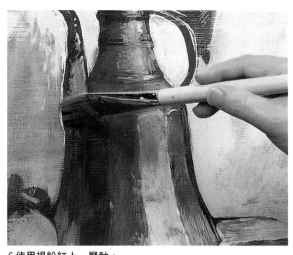

6.使用褐粉紅上一層釉。

6. Apply a light coat of glaze using Brown Pink.

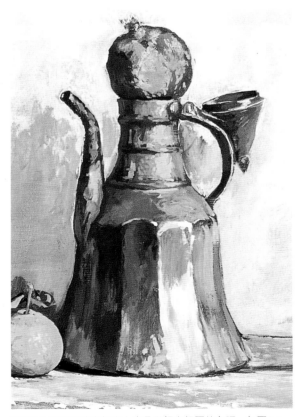

7.橘子的顏色反映在銅壺上應是與銅壺相同的色調,如圖5.。

7. The color of the oranges reflected in the surface of the pot should be the same copper color as used in picture number 5.

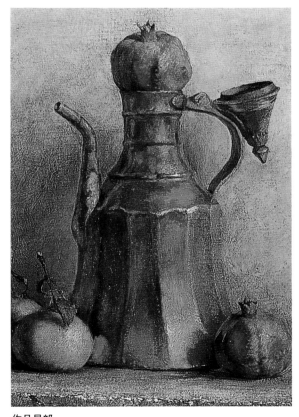

作品局部

A detail of the reference work.

木桌的描繪
Expressing the Wooden Table

1.注意桌緣與桌面光度之不同。

1. Grasp the difference in shading between the edge and the top of the table.

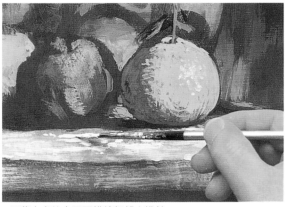

2.沿著木桌的水平面描繪細部之橫紋。

2. Apply horizontal strokes with the brush following the grain of the wood.

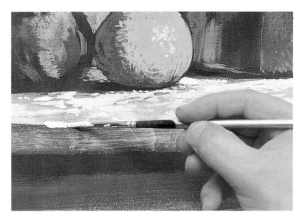

3.使用白色顏料表現桌沿磨損的部份。

3. Use white to pick out the areas where the edge between the top and the side have destroyed.

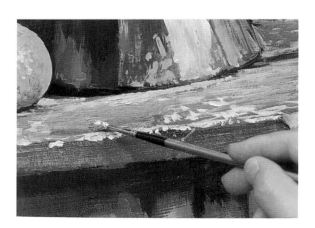

4.改變筆勢力道以使桌面與桌沿形成對照。

4. Alter the strength of the strokes on the surface of the table in contrast to the broken edges.

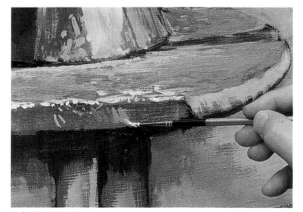

5.在桌沿描繪出刮痕及木屑。

5. Pick out the scratches and grain in the edge of the table.

6.讓漆乾燥後上釉打光。

6. Allow the paint to dry then apply a glaze.

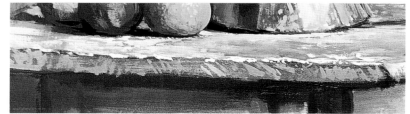

桌沿的刮痕及桌面的刮痕均爲木桌之特色而不應忽略。木紋則是另一個重要的特色，但它們的強度應小心處理，否則整個畫面將會被破壞。特別是在描繪一個如桌面的光滑平面時，木紋僅以畫刷製造出刷痕即可表現其質感。

The scratches that can be seen in the edge and surface of the table are one of the characteristics of wood and should not be missed. The grain is another important characteristic, but its comparative strength from different viewpoints must be considered or the picture will be ruined. In particular, when working with a flat surface like the top of a table, it should be sufficient if the grain is expressed simply through the strokes of the brush.

原始照片

A photograph of the subject

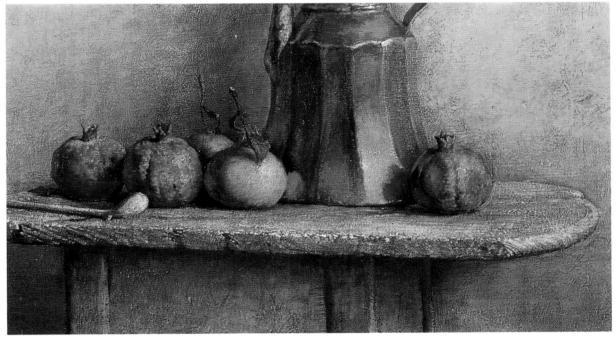

作品之局部　　　A detail of the reference work.

銅壺與其他各種材質之組合

A Combination of a Copper Pot with Various Textures

從此作品中，我們可以看到一個銅壺為各種不同材質之物品所圍繞，包括陶器、瓷器，各種金屬，木頭及蛋等。用來表現銅壺質感的釉料是焦黃色顏料調成的；但很明顯地，僅此一種顏料並不足以表現銅器的材質。其中也夾雜了灰／綠色顏料以代表銅鏽以及此物件的歷史。茶壺的把手對畫面的構圖來說極為重要。但須當心不要忽略了壺面的凹洞，因其對鐵鑄成之物品來說是極為普遍的。在牆上的鐵圈也以同樣的方式處理。

In this example we can see a copper subject surrounded by a variety of textures including pottery, china, various metals, wood, eggs etc. The glazing used to express the color of the copper is based on Transparent Burnt Sienna, but obviously it is impossible to express the color of copper through this alone. There is also a shade of grey/green in it that hints at verdigris and the long history of the subject. The handle of the jug plays a major part in the composition, but you should be careful not to overlook its slightly pitted surface which is typical of cast metal objects. The same is true of the rust on the wrought iron wall ornament.

銅壺所使用的釉色是透明的焦黃顏料。

The glazing on the copper jug consists mainly of Transparent Burnt Sienna.

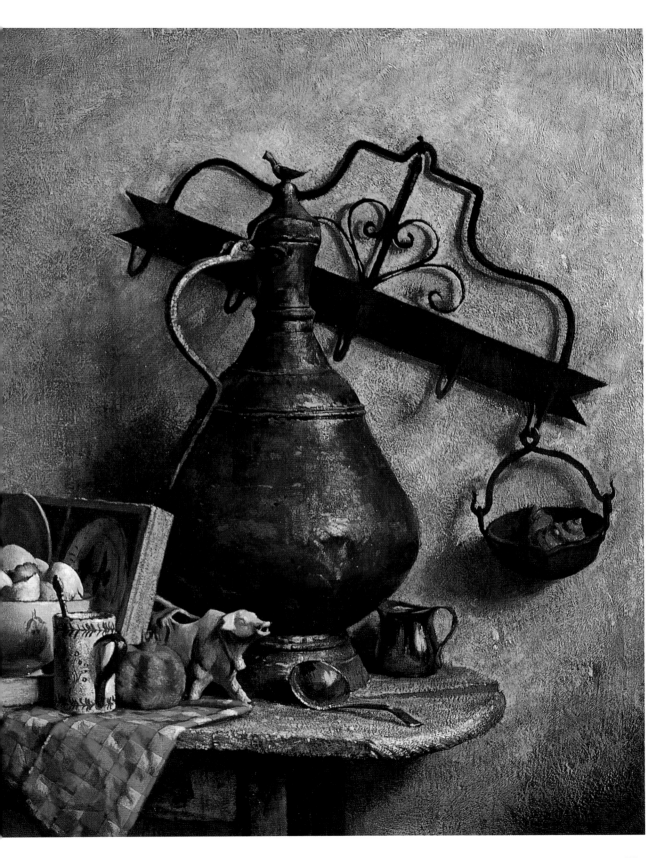

石榴
Pomegranate

　　一個乾枯的石榴表面是不尋常的亮紅色及褐色，因此水果的線條則創造出有趣的畫面。這些線條及外表的質感能讓你畫出一幅逼真的畫作。

The skin of a dried pomegranate retains an unexpectedly bright red and brown color while the contours of the fruit create an interesting expression. It is the expression of these contours and the rough texture of skin that will allow you to produce a realistic painting.

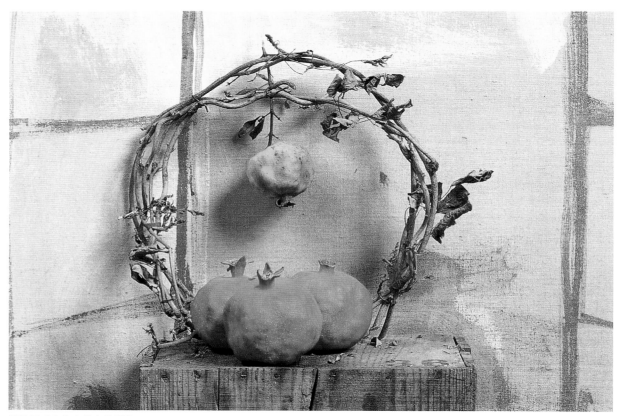

照片顯現出表皮鮮亮的顏色

A photograph of the subject showing the vivid color of the skin.

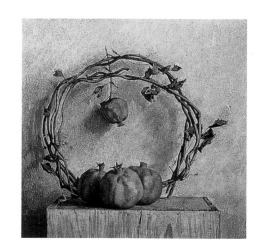

完成圖

The finished painting

漸漸勾勒出表皮的質感 Build Up the Rough Texture of the Skin

1.用單一色調描繪出物件。

1. Grasp the overall shading of the subject using a single tone.

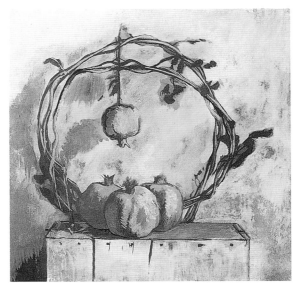

2.以白色描白光源部份,使用短筆觸創造表皮粗糙的效果。

2. Build up the highlights with white, using short strokes to create the rough texture of the skin.

3.石榴之畫作。待顏料完全乾燥之後再上光。

3. The picture of the pomegranates. Allow the paint to dry completely before moving on to the glazing step.

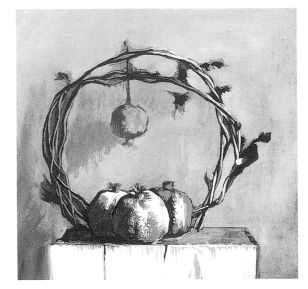

將色調藉上光程序作處理
Add the Color of the Subject Through Glazing

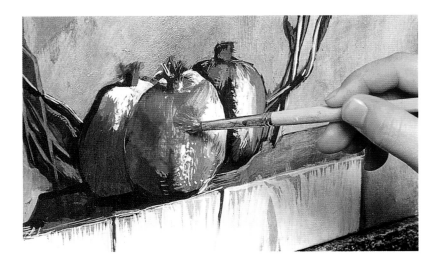

4.以石榴的原色上光。

4. Apply glaze with the color of the pomegranates.

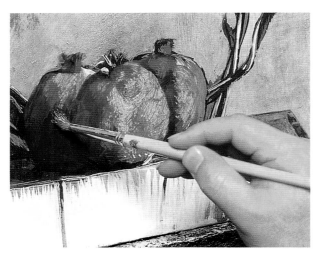

5.畫面全部上釉，包括陰影部份。

5. Apply the glazing over the whole area, including the shadow areas.

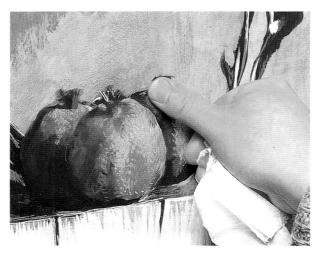

6.用手指或布擦掉畫料太多之部份。

6. Use a finger or a cloth to rub off the glaze and neaten up the areas which have received too much paint.

56

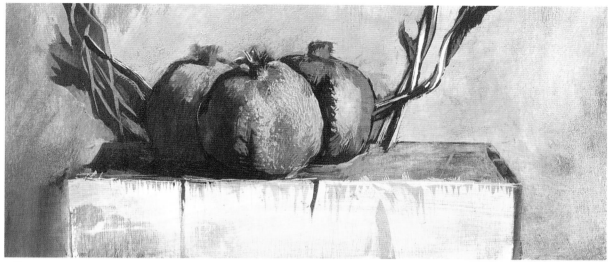

7.第一次上釉後的石榴。短筆觸的部份以及不同的顏色均是經由手指摩擦畫作表面而形成的粗糙質感。

7. The pomegranates after the first coating of glaze. The color of the areas of short brush strokes and the different color that was created by rubbing the surface with a finger combine to create a feeling of the texture of the rough surface.

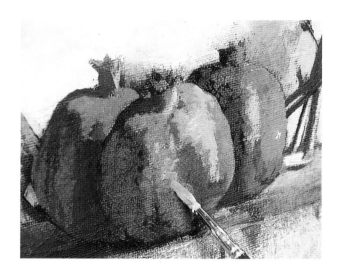

8.再次加強石榴的色度。

8. Build up the bright color of the pomegranates for the second time.

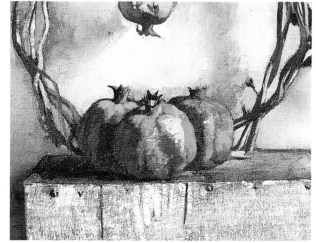

9.加強色度之後，待顏料乾了再上第二次釉。這步驟必須重覆數次，此畫作才算完成。

9. After the color of the pomegranates has been built up again, allow it to dry before applying the second coat of glaze. This stage must be repeated numerous times before the picture is complete.

木箱的質感
The Texture of the Wooden Box

乾刷及上釉
Drybrush and Glazing

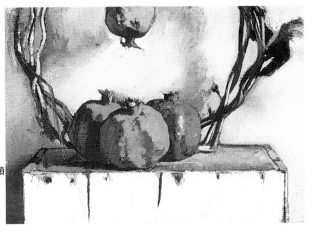

1.在木紋及木頭退色的質感表現出來之後,木箱表面上了一層白色顏料,以表現木箱的平面性。木紋則隱約由白色顏料層後透出。

1. After the grain and discolorations of the wood have been applied, a coat of white is applied over front surface to stress the flatness of the box. The pattern of the grain will show through the white weakly.

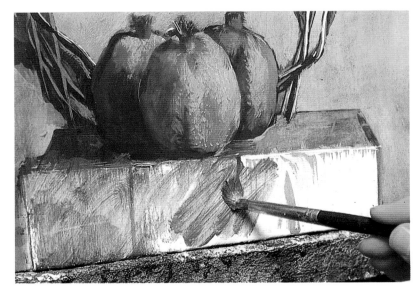

2.全部塗上一層釉色。

2. Cover the surface with an Umber glaze.

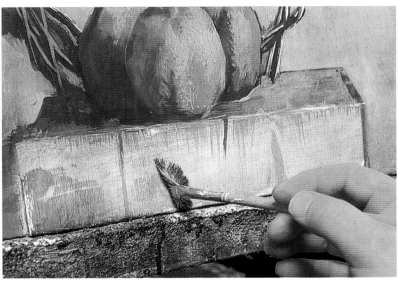

3.用扇形刷塗勻顏料。

3. Spread the paint using a fan brush.

58

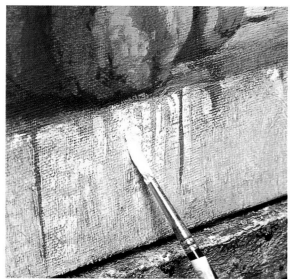

4.輕輕握住筆刷,在表面以白色顏料及乾筆刷強調木頭之接縫處,及木頭表面的不平處。

4. Holding the paintbrush lightly, go over areas of the surface using white and drybrush technique to accentuate the joints in the wood and the unevenness of the surface.

5.再上一層釉色。當其半乾時,壓入畫布之中,以營造出一種上釉後的凹陷感,並加強物件的實體感。

5. Apply a coat of glaze and when this has partially dried, rub it into the canvas using the palm of the hand. This produces a more pronounced contrast between the glazing in the depressions of the texture with that on the raised areas and creates a strong impression of solidity.

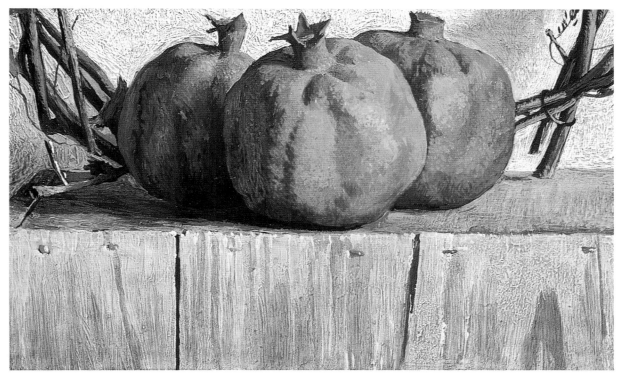

6.部分完成圖　　6. A detail of the reference work.

細部滕枝畫法
The Fine Details of the Vine

先刮表面再上釉

細滕枝以及小苞可由厚實顏料所畫成的小叢中畫出，而畫法爲先在背景處塗上厚厚一層作爲牆壁，再刮出滕枝的形狀，待其乾燥之後上釉，便可表現出叢密的質感。

Created by Scratching the Surface then Glazing

The thin branches and small buds on the vine are expressed through thin grooves created by laying down a thick coat of color for the wall in the background then scratching the surface before it has dried. When the glaze is applied later, it will accumulate in these grooves and produce the fine detail of the branches.

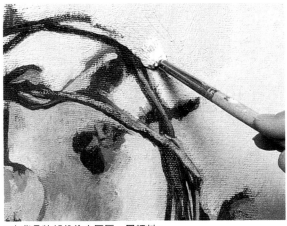

1.在背景牆部份塗上厚厚一層顏料。

1. Apply a thick coat of paint for the background wall.

2.細滕枝是以筆柄後端輕刮畫面而成。顏料乾後並上一層釉料。

2. The thin branches of the vine are created by scratching the surface with the handle of the brush. A glaze is applied once the paint has dried.

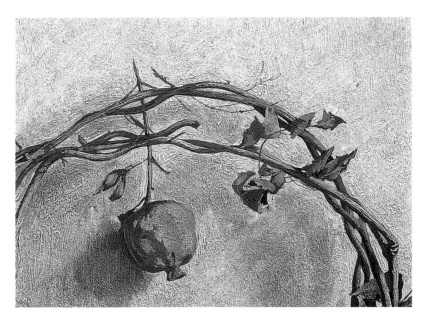

3.完成圖部份。

A Detail of the Completed Picture

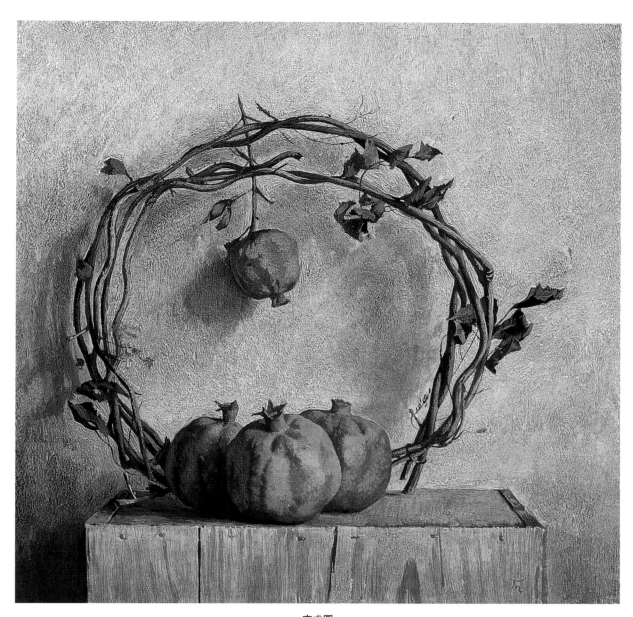

完成圖

The Finished Picture.

舊皮包
An Old Leather Case

1.先以明亮的顏色在彩度低的背景上勾勒出皮包之形狀。

1. Paint the shape of the case in a bright color over a dark ground.

2.以焦黃色與褐粉紅色調色。

2. Create a glaze mixing Burnt Umber and Brown Pink.

3.在彩度高的表面畫上白色反光部份。以及污漬部份，使兩者成鮮明對比。

3. Add the reflected light in the bright surface and the dirty areas, producing an exaggerated accent through the contrast.

4.使用反覆描白及上光的技巧來表現光線反射的部份，且表現出皮革的質感。

4. Use repeated picking-out and glazing, to express the areas where the light is reflected and where it is absorbed to produce a feeling of the texture of leather.

與金屬的堅硬相較，皮革更柔軟地反射及吸收燈光，如果我們仔細觀察細節，我們將可看到皮包的皮革有些地方是很髒很舊的，呈現出許多不同的質感。表現此質感的方法是全面處理陰影，全面上釉，然後加強細部，且再次上釉最後才修飾細節。

Compared with the hardness of metal, the light is reflected and absorbed to a much softer degree in the leather of the case. If we look at the details we see that it is worn and dirty in parts creating a delicate variety in textures. The technique used to express this is to grasp the overall shading in an exaggerated way then lay a coat of glaze over it. Next the highlights are picked out then another coat of glaze laid down, this being repeated several times. Finally, the details are added.

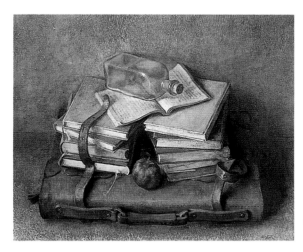

參考作品
The reference work

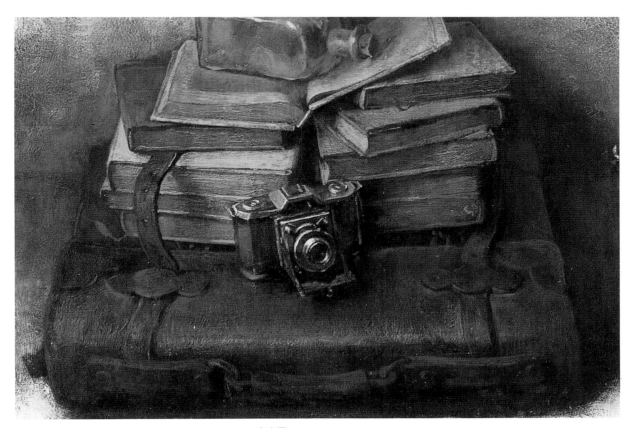

完成圖　　　A detail of the reference work.

瓶子
A Bottle

表現透明感時須特別注意要將背景及內容物透過玻璃瓶表現出來，如果背景有所扭曲，那麼便表現其扭曲的一面。如果模糊不清，則模糊不清。這就是表現玻璃質感的秘訣。

One of the main points when expressing the transparency of a glass bottle is to show the contents and the background through the glass. If these appear distorted, then they should be distorted, if they appear blurred, then they should be portrayed blurred. This is the secret of expressing glass.

光源表現法則

瓶子的光源大多在瓶底頸部及其彎曲處，換句話說，瓶子的形狀是經由光源決定的，故須小心處理。

The Rule Governing the Position of Highlights

The highlight in the bottle appears in the depression at the base of the neck and on the top of the curve of the shoulder. The height of the highlight varies according to the angle and shape of the shoulder. In other words, the shape of the bottle is expressed through the position of the highlight so care should be taken when positioning this.

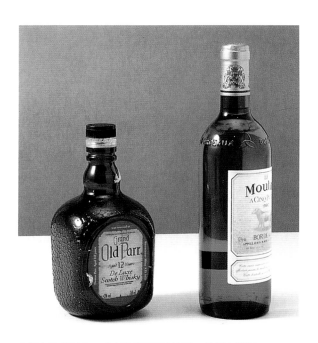

酒瓶有兩處反光。威士忌的瓶頸有形狀，故反光出現在凹陷處及頸頭。

The wine bottle has a highlight in two places. The whiskey bottle has a constriction in the neck so the highlight appears in two places, in both the depression and on the crown.

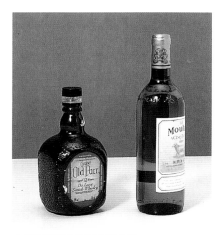

在光源移動時部份呈螺旋狀。

As the light moves, the highlight travels through a circular course.

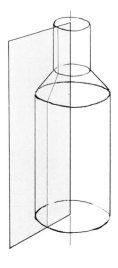

反光出現在紅線上。

Highlights appear on the line shown in red.

反光的位置有某些規則可循，故應小心處理它在物件上之位置。

There are rules controlling the position of the highlight and care must be taken as its placing decides the shape of the object.

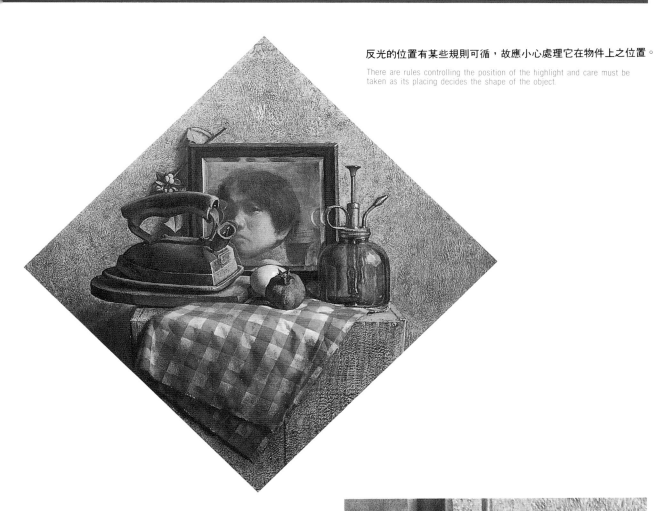

玻璃厚度不一且彎曲度不一使得光線及裡面的鐵管線看來扭曲。

Differences in the thickness and curvature of the glass cause the light to refract and the metal pipe inside appears distorted.

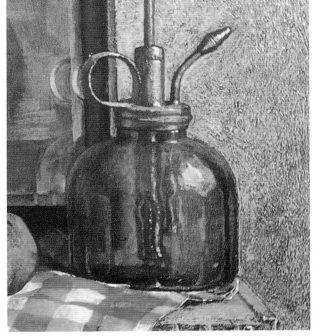

有色玻璃瓶
A Colored Bottle

當描繪玻璃時上光可增加硬度。其它方法則頗難表現出其質感。

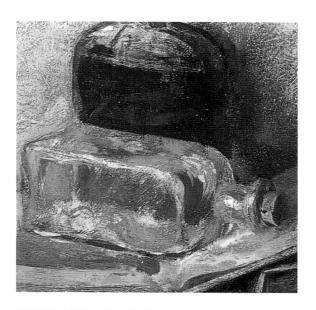

1.背景的顏料乾了之後,使用白色顏料加強玻璃表面的反光及光線。

1. Once the background has dried, use white to add the highlight and light grey for the surface of the glass.

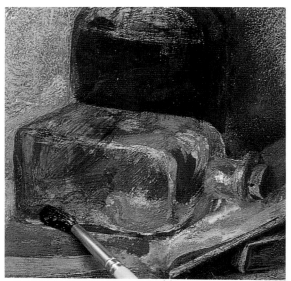

2.使用綠色溶劑上光。

2. Make a glaze using Sap Green and apply to the bottle.

3.再次加強反光部份。

3. Build up the highlight.

4.再加強背景細部且整理瓶子的形狀。

4. Pick out the details of the background and neaten up the shape of the bottle.

When portraying transparent glass glazing should
be used to create the hard feeling of the glass. It is
very difficult to express the light reflected within
the glass using any other technique.

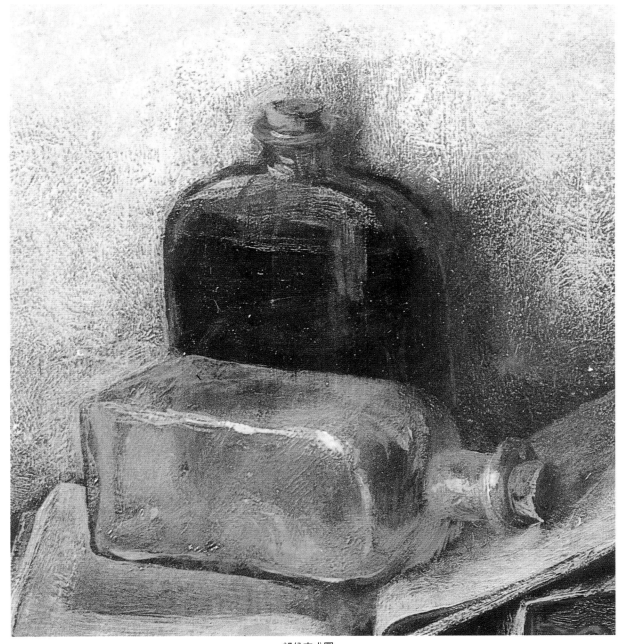

部份完成圖

A detail of the bottle.

Instruments, A Doll and A Pattern

樂器，洋娃娃及花樣

弦琴的弦應以直線表示。不一定每次都能看到整條弦，所以該模糊的地方可用釉料稀釋。

在表現瓷器花紋時最重要的是觀察其如何沿著表面成形。爲了達成此目標，應注意觀察其如何表現陰影且形狀如何與背景融合。一旦你能注意此點，花紋能幫助你強調其質料、位置、及物品的表現性，如此範例所示，雖然娃娃僅是一人工之物品，但應有如人體般的平衡感，臉部的僵硬應與布料成反比。

The strings of the lute should be expressed through taut, straight lines with no slack in them. It is not possible to see all the strings so the areas that are obscured in the subject should be observed then glazing applied to hide the same areas in the picture.

The important point when applying the diamond pattern to the china object or the pattern of the table cloth is to observe how it follows the surface of the objects. In order to achieve this, care should be taken to grasp the shading of the surface accurately and show how it joins the background. Once you are able to accomplish this the pattern will help to accentuate the texture, position and presence of the subjects as it has in this example. Although the doll is an artificial object it should contain the same sense of balance as is apparent in the human figure. The hardness of the face should be expressed to contrast it with the texture of its clothes.

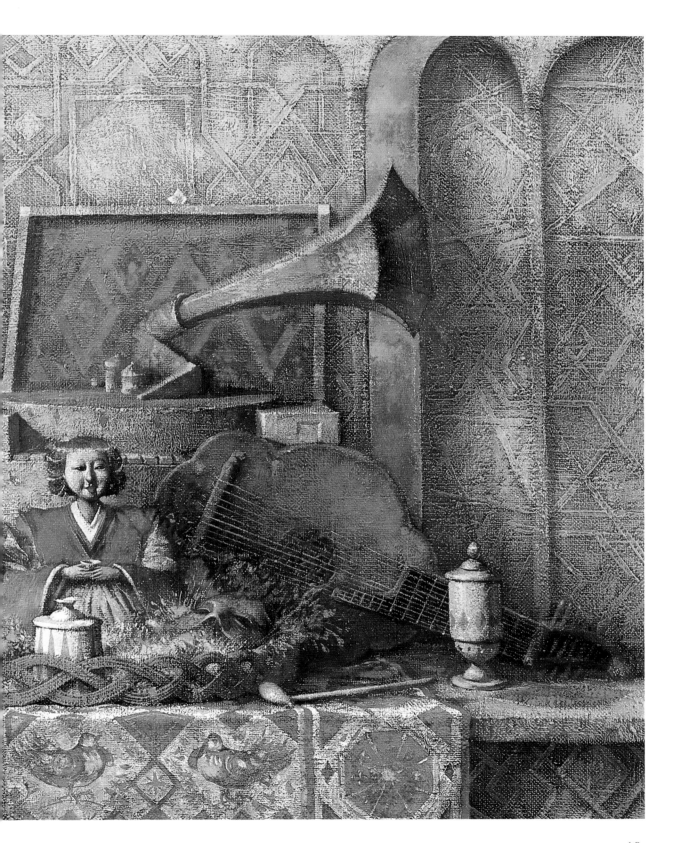

照相機，鏡子等等
A Camera, Mirror Etc.

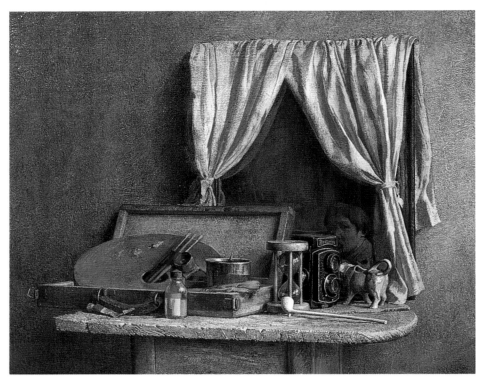

完成圖
The Finished Picture.

光及金屬
Gleaming Metal

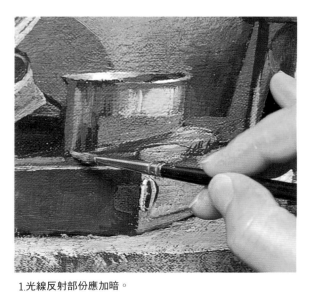

1.光線反射部份應加暗。

1. When adding the reflected light, keep it a little dark.

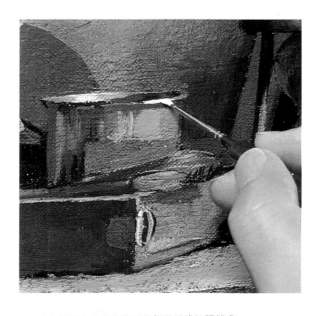

2.用白色顏料在前方塗抹以示杯子前緣的距離感。

2. Use white to build up a strong highlight on the front edge of the cup and create a sense of distance between it and the far side.

爲求表現攝影機鏡頭及金屬部份，其它亮度高的部份應變暗。一般説來，材質愈硬則光暗對比愈強。

In order to express the highlights found in the lens and metal of the camera effectively, it is necessary to tone down the other bright areas. Generally speaking, the harder the substance, the stronger the contrast between the highlights and shadow areas.

物件之攝影
A photograph of the subject.

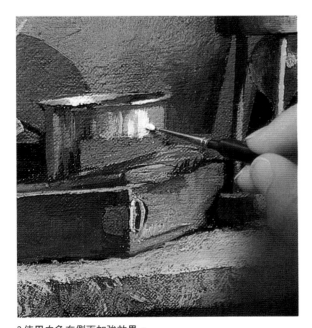

3.使用白色在側面加強效果。
3. Use white to create a strongish highlight on the side.

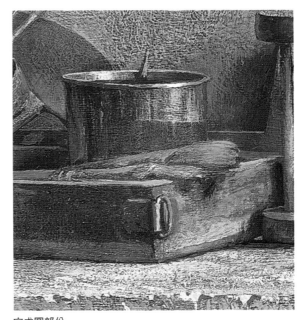

完成圖部份
A detail of the finished work

71

鏡頭
The Lens

形狀表現於凸透鏡處
The Highlight Appears on the Convex Lens

相機的完成部份
A Completed Section Showing the Camera

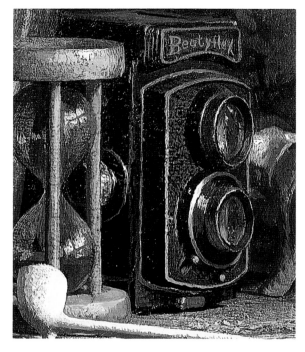

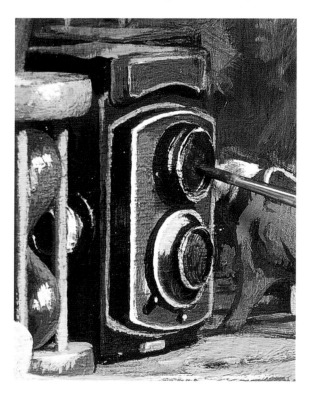

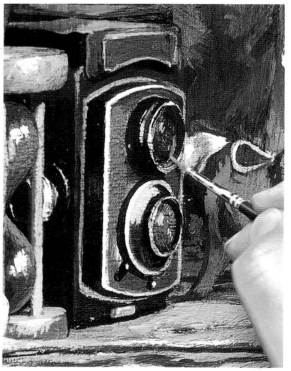

1.畫鏡頭時使用淺灰色,待其乾了之後再用淡紫色。

1. Paint the lens using a bright grey then once this has dried, add the mauve of the lens coating.

2.加上反光。右上較強,左下較弱。兩個鏡頭幾成平行,因此反光應大致出現在同一處。

2. Add a highlight, stronger in the upper left and weaker in the lower right, following the curvature of the lens. The two lenses are parallel to each other so the highlights should appear in approximately the same place on both.

攝影機主體
The Camera Body

表現凹凸表面使用上釉法

如果黑色顏料是用來表現其主體，則畫布上似乎出現一黑洞而使畫作失去真實性。

在表面加上陰影然後以黑色上釉可製造出特殊的質感效果。

Use Glazing to Express the Granulated Texture of the Surface

If black paint is used to express the camera body, it will look like a hole in the canvas and the picture will lose realism. Apply shading to express the granulated surface of the body then go over this with a black glaze and it will produce the unique texture of camera body.

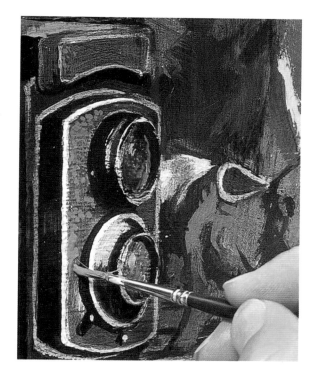

1.用灰色來表現攝影機表面的真實性。

1. Use grey to recreate the texture of the surface realistically.

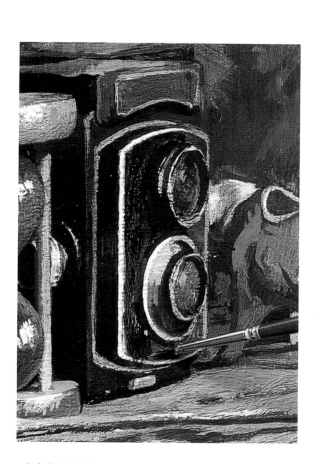

2.灰色乾後以象牙灰上釉。

2. After the grey has dried, apply an Ivory Black glaze.

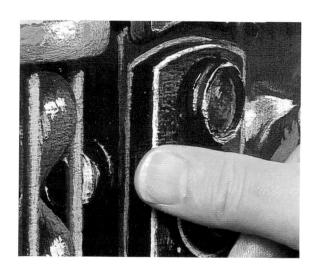

3.將象牙黑釉彩以手指抹勻使其底下之顏色可顯見。

3. Rub the Ivory Black glaze with a finger to control the way n which the lower color can be seen.

畫用液瓶子

　這個常用且有些不透明的瓶子可經細心描繪後在瓶頸部份顯現其不透明度。

A Painting-Oil Bottle

The thickness of this well-used, slightly opaque glass bottle can be expressed through the careful positioning and shape of the highlight and by showing the build-up of opaque glass in the shoulders.

油壺

油壺的金屬質地應予以強調。
油或溶劑以上釉表達。

An Oil Pot

The metallic texture of the oil pot should be somewhat stressed.
The color of the oil or varnish is applied through glazing.

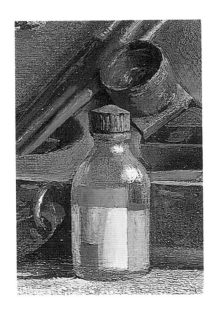

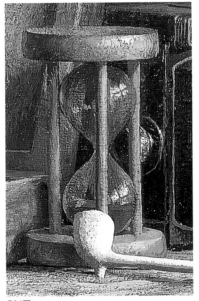 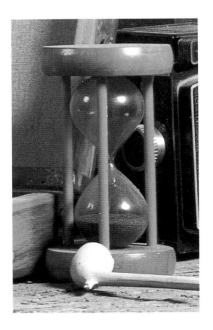

砂漏

上亮光漆的木頭框架是油畫中最易表現之物件。木頭的質地以油彩顏料表現，而後以溶劑上光；製造此物品之手續亦相同。
如小心表現光線於三個支架柱上之位置，則可處理其間的空間。照片中的光線及畫中的光線不同處在於照片之光線來源為鎂光燈。而畫中的光線則由窗戶而來。

An Hourglass

The varnished wooden frame of the hourglass is one of the easiest subjects to express through oils. The wood texture is applied using oil paints then glazed with varnish using much the same techniques as were utilized to manufacture the subject.

Careful attention to the way in which the light hits the three posts will allow you to express the space between them. The difference between the highlight in the photograph and that in the painting is due to the fact that the reflected light source in the photograph is from the flash, whereas that in the painting shows the reflection of the light coming through the window frame.

鏡子

鏡子的表面是平滑的，故反光與鏡頭或瓶子之反光均不同。直線且尖銳的反光爲其所呈現之結果。在表現鏡子或窗戶時表面的反光均須小心處理。

The Mirror

The surface of the mirror is flat so the highlights will appear different to those in the lens and the bottle. The sharp, straight highlight down the edge is the point to watch. It is also important when depicting a mirror or window to express the subtle reflections that sometimes appear in the large surface.

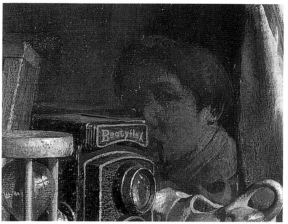

鏡子局部圖

A Section of the Finished Picture of the Mirror

1.用大略的描繪來表現鏡中倒影。

1. Use rough shading to pick out the objects reflected in the mirror.

2.鏡中自畫像。

2. A self-portrait appearing in the reflection.

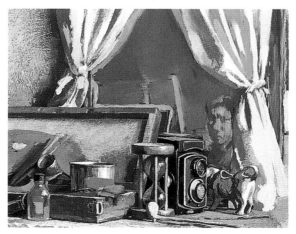

3.畫作完成待乾。

3. After the painting is complete, allow it to dry.

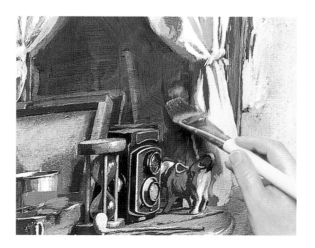

4.用光油來製造光亮。鏡中影像暗較能表現反光。

4. Use ??? to create a glaze, darkening the image inside the mirror heighten the feeling of it being a reflection.

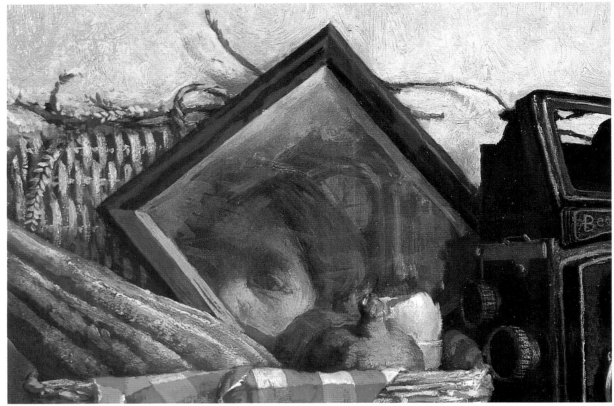

白色反影可顯現鏡中構圖

The subtle reflections in the mirror are added in the last stage using a thin white glaze.

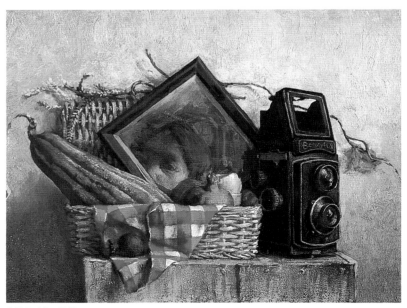

直線影射這是鏡子。

The sharp, straight highlight down the edge shows that it is a mirror.

玻璃板

表面不甚明顯的反光及反影均比鏡子淡，但玻璃的存在可
利用物件是否透過玻璃來反映。

Sheet Glass

The subtle halation of the surface and the
reflections which are not as pronounced as in a
mirror are what characterize glass. Again, the
existence of the glass can be stressed through the
contrast between the objects that are seen through
the glass and those that are not.

參考圖　　An Example

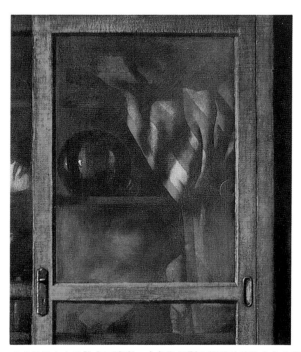

玻璃後的布有些許多不清晰，白色影子則可證明玻璃的存在布紋在
玻璃前的部份摺痕極清晰。

The cloth behind the glass is depicted slightly blurred then a weak glaze of
white is added in places to express the subtle reflections in the glass.

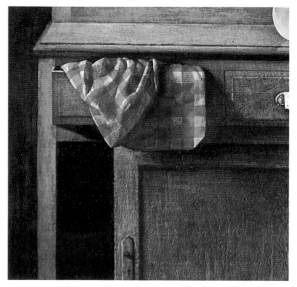

抽屜裡的布料依據皺摺的明暗表現方格條紋。

Pick out the stripes of the cloth in front of the glass following the shading of
the folds.

水面
The Surface of Water

此例中實體及它們的倒影均給畫作一定之深度。但同時波浪的反影及畫布的質感可用來創造表現水的感覺。

In this example the actual objects and their reflections are painted accurately to produce a feeling of depth. At the same time the reflections of the waves and the texture of the canvas are used to create the feeling of the water itself.

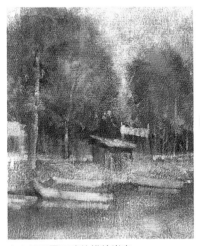

水中倒影需正確的描繪出來。

The reflections of the surroundings are depicted accurately.

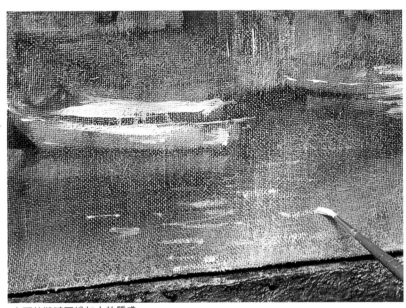

水面的漣漪可增加水的質感。

The rippling waves are added to recreate the texture of the water.

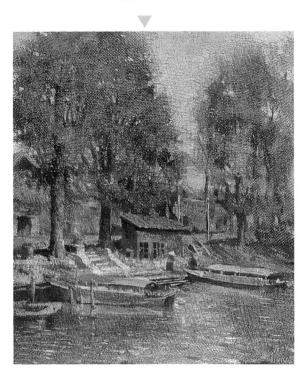

完成圖

The Finished Picture

水面像鏡子一樣可以反映週圍的環境，同時也可以增加深度。但它本身也是存在的實體。這兩者之間的平衡是表現水面質感的密訣。

Water reflects its surroundings like a mirror, producing a feeling of depth. At the same time it has an existence of its own and the balance between these two characteristics provides the key to expressing this subject.

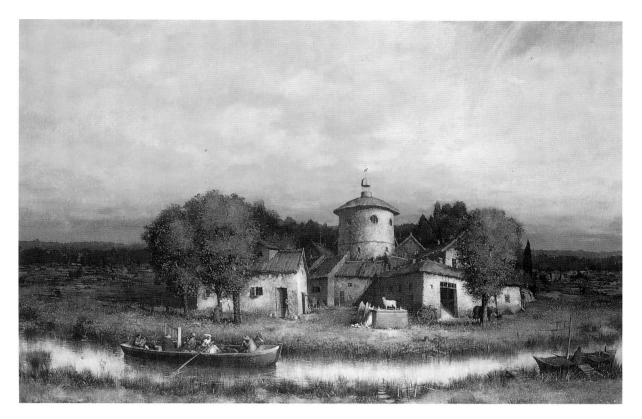

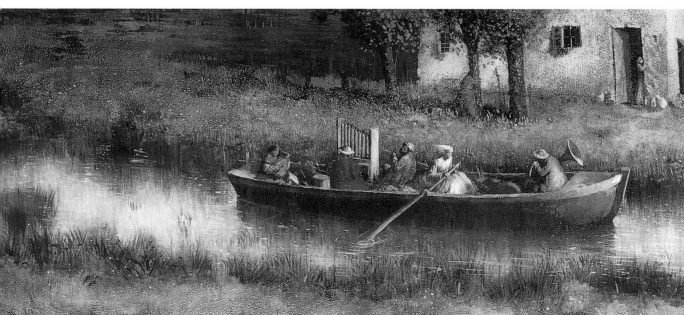

水面反映天空及周圍的環境。漣漪則創造了水面的質感。

The reflections of the bright sky and surroundings, added to the ripples create an expression of the surface of the water.

水面的畫法
The Process Creating an Expression of Water

1.先上底色於畫布上,再將亮處以白色
顏料勾勒出來。

1. A ground of an Umber hue is laid down on the
canvas then the bright areas are picked out using
white.

2.船的影子是由筆刷縱向勾劃出來的。

2. The shadow of the boat is applied using vertical
strokes of the brush.

3.以綠色上光;應在整個畫面上上光,
包括草地的部份。

3. Apply a glaze of Sap Green over the whole
picture, including the areas of grass.

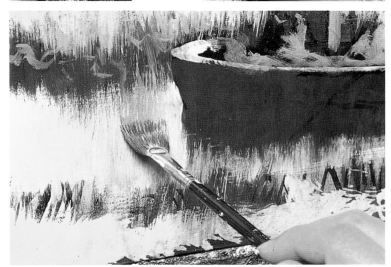

4.用布擦拭特別光亮的部份以及船隻附
近的部份。

4. Use a cloth to make slight adjustments to the
glaze in the particularly bright areas and around
the border of the boat.

5.加上草的倒影。

5. Add the reflections of the grasses.

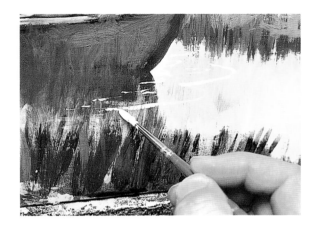

6.使用白色描出漣漪來表示事實上是水。且應表現出其位置感。

6. Use white to pick out the ripples in the surface of the water to show that
it is in fact water and also to show its level relative to its surroundings.

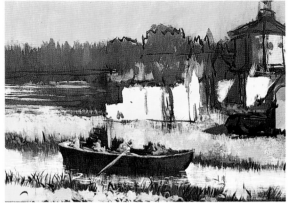

7.一旦明暗已經標出，顏料及釉料交互上色後，畫作便完成了。（見
79頁完成圖）

7. Once the shading has been laid down, repeated alternate coats of the
color of the objects and glaze are built up and the picture is completed.
(see page 79 for the finished result)

背景牆壁之圖樣

The Pattern of the Wall in the Background

加強局部

如果背景畫得太仔細，則將搶去畫中靜物的風采。但如果畫得太模糊，則靜物會失去真實感。在此例中，牆紙的花樣和直紋應以多層的顏料表現其存在。然後整個畫面應再上光以使牆壁與整個畫面調和。

Build up in Sections

If the background is painted in too much detail it will detract from the still-life in the foreground. On the other hand, if it is too rough, the still-life will lose its feeling of reality. In this case, the pattern and pillars should be added using a thick coat of paint to give them a firm identity, then the whole area should be gone over with a glaze to make them blend in with their surroundings.

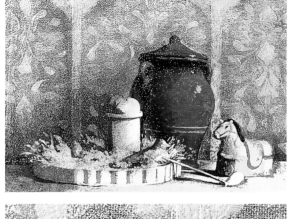

2. 一旦花紋以白色畫出後，也應再以釉料塗過。

1. The build-up of paint will be quite visible in the finished picture so care should be taken to grasp the shape accurately.

2. Once the pattern has been built up using white, it should be gone over with a glaze.

1. 由於上釉時可很明顯看出多層相疊的顏料。因此應小心的描繪花紋的型狀。

陶器的表面 The Surface of the China Pot

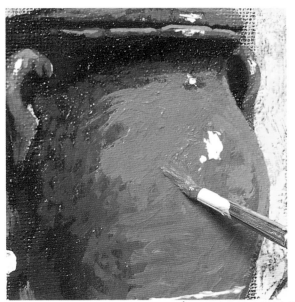

1.配合其它物件來加強陶壺的顏色。因為陶器是土作的，所以在繪陶壺時，你應想像自己是在製造一個陶壺。

1. Add the color of the pot with relation to the shading of the subject. The pot is made of earth as are the paints you are using so you should think of it as creating the pot yourself.

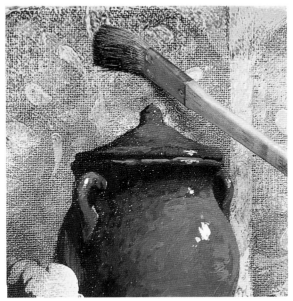

2.在背景處上釉。

2. Add the glaze to the background.

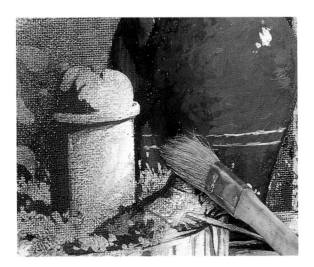

3.繼續在其它物件以及陶壺上上光以保持整個畫面的和諧。

3. Continue the glaze over the pot and other objects in the still-life to create a harmony of color.

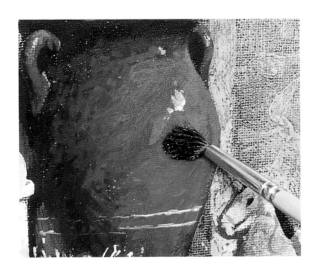

4.在陶器上加一層赤紅色釉料來加強紅色的效果。在上釉時加強色度也是陶器上釉時常見的手法。

4. Add a coat of glaze using Carmine to strengthen the red. Adding a gloss to the surface while dampening the highlights makes this process similar to the glazing of the pot.

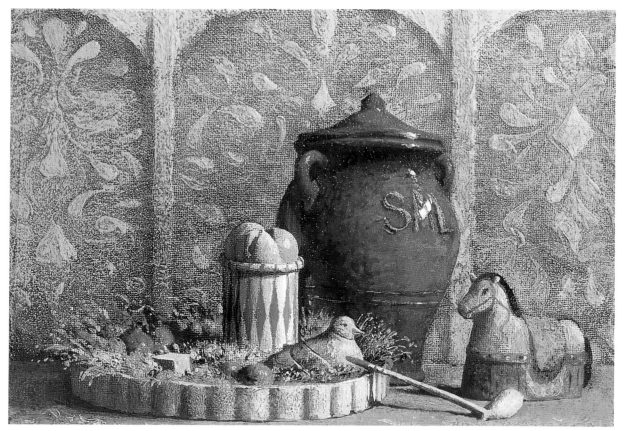

83頁的完成圖　The Completed work From Page 83

完成圖之局部　A detail of the finished work

白色物件之不同質感

即使同是白色物件，它們在各種色度上也有所不同。例如瓷器的白有著藍色的色調，而蛋殼的白則帶有黃色調。而光度亦有不同之處。瓷器的光度使其表面顯得光滑，而蛋的光度則表現出它的粗糙及鈣質質感。布的顏色則是與瓷器相仿，但它的質地則以表面上的細摺來表現。

Differences in the Texture of White Objects

There is a great deal of tonal variation between different white objects, for instance, the blue cast to the white porcelain or the yellowish white of an egg. Again the highlights are different, the highlight in the porcelain expresses the shiny surface whereas that of the egg expresses the rough calcium feeling. The color of the cloth is similar to that of the porcelain but its texture is expressed through the fine creases in its surface.

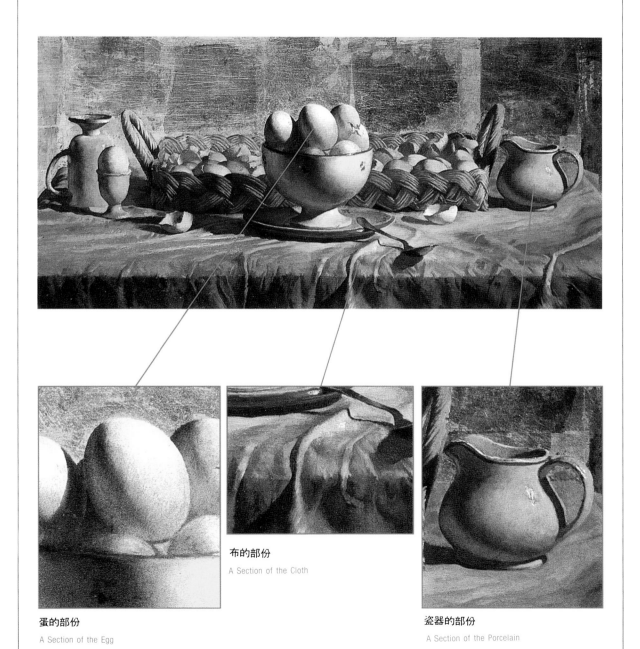

蛋的部份

A Section of the Egg

布的部份

A Section of the Cloth

瓷器的部份

A Section of the Porcelain

白色瓷水壺以及金邊杯子
A White Enamel Pot and a Gold Rimmed Cup

白色的表現方式

當畫白色物品時,純白色可用在光度高的地方,但壺體的其他部份則不應用白色。灰色可用爲壺的主體的顏色。至於灰色是否能製造出白色的質感則有賴於附近物件的明度來決定。

Expressing White

When painting a white subject, white may be used in the highlights, but a bright white should not be used in the rest of the object. Grey is used for the body of the pot and whether this creates an impression of white or not depends on the relative brightness of the surrounding wall or table.

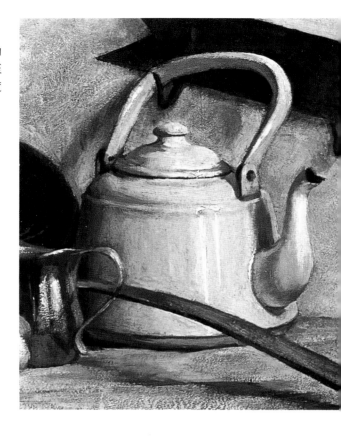

金色的表現方式

當使用金色質地時,應利用表面的倒影及陰影來表現其感覺。即使金色直接貼於畫布上,也無法創造出金色的質感。這裡我們用白色來當底色,然後再用明黃色上釉。

Expressing Gold

When expressing gold, one has to do so through the reflections and shadows in its surface. Even if gold leaf is applied to the canvas, it will not create the impression of gold. Here we use bright white as an undercoat for the highlight, then apply a glaze of Cadmium Yellow over it.

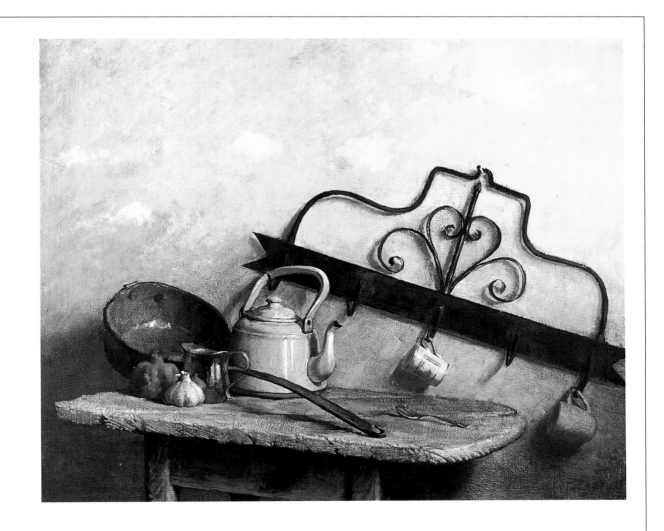

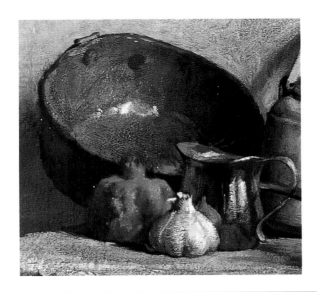

光亮點之不同處
Differences in Highlights

煎鍋：煎鍋的底部發出暗淡的光線。

Frying Pan： The highlight that can be seen in the base of the old frying pan emits a dull light.

銀製水壺：這個壺的表面泛出倒影，且不應僅由一點來反射光線而是窗型的反射光線。光線在大蒜上之表現則需注意明度。

Silver Pot： The surface of this pot is very reflective and the light source should be expressed not through a point, but in the shape of the window. When expressing the reflection of the garlic, pay attention to the color values.

建築物的牆壁
The Wall of a Building

為了表現牆壁的厚重與堅實，要記得使用一層層的顏料，而在作畫時應小心不要漏畫任何裂縫、凹痕及表面的污漬。

In order to express the volume and solidity of the wall, it is important to apply a thick coat of paint. Care should be taken when painting not to miss any cracks, dents or dirt on the surface.

1.用黑白兩色描出形狀和陰影。

1. Grasp the shape and shading in black and white.

2.用畫刷的痕跡盡量的表現牆壁的顏色。一旦顏料乾透之後，加上一層釉色用扇形刷將刷子塗上的顏料在畫面上塗均。

2. Add the color to the wall making the most of the brushstrokes. Once the paint has dried, add a coat of glaze, using a fan brush to rub the paint into the surface.

3.使用白色來加強牆上的磨損。

3. Use white to accentuate the damage to the wall.

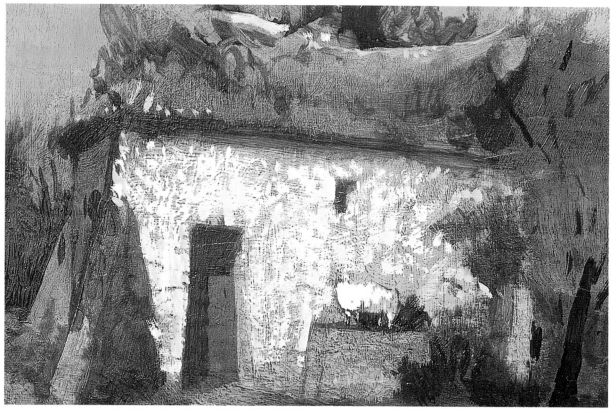

4.白色顏料乾了之後,如同步驟2一般上釉。一層層的上釉,但要小心不要破壞陰影部份,如此才能讓牆壁有眞實感。

4. Once the white has dried, add a glaze in the same way that you did in the step 2. Build up the glazing, taking care to preserve the overall shading, to create the feeilng of the real wall.

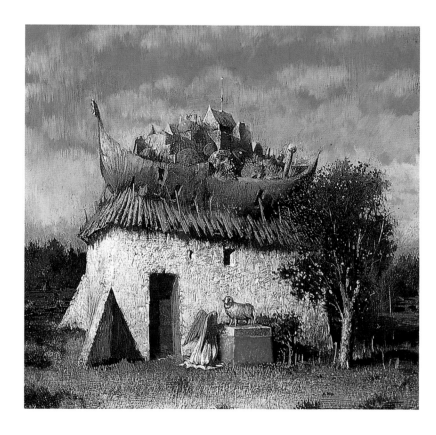

完成圖

The Finished Picture.

動物
Animal

動物毛皮的顏色及光澤會因光線的方向而改變，且亦會因為動物站立方式及形狀而有所不同。只要你記得這個原則則畫起來便很容易。使用細畫筆，按照毛髮生長之方向來作畫。重複如此作畫，間接以釉料上光，就可以完成複雜的動物毛皮畫法。

The color and brightness of an animal's coat varies according to the direction of the light, the shape of the animal and the direction it is standing in. As long as you do not forget this, it is quite easy to express the coat, using a thin brush and applying the strokes in the direction in which the hair grows. Through repeated applications in this way, alternated with glazes, a complicated expression of the animal's coat may be achieved.

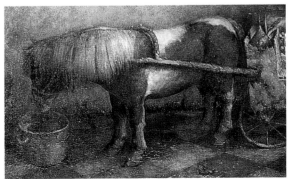

完成圖
The Finished Picture

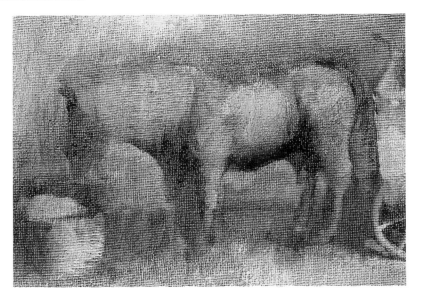

1.首先標出明暗。
1. Apply the overall shading of the picture.

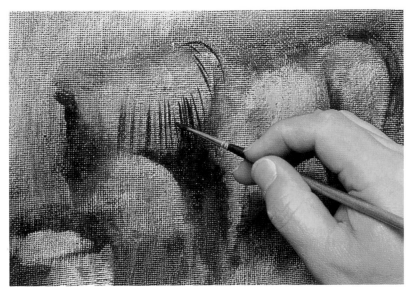

2.使用深色來畫鬃毛。
2. Paint the hair of the mane using a dark color.

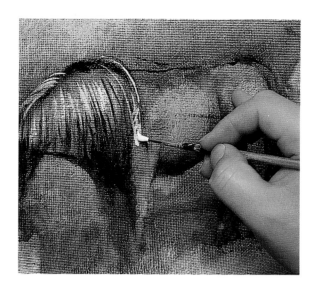

3.小心頸部的曲線。油亮部份特別注意。

3. Bearing in mind the curve of the neck, pick out the mane, concentrating on the light areas.

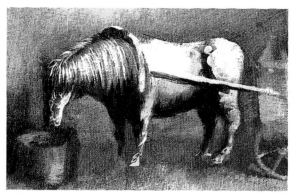

4.使用白色描繪全身的形狀。

4. Pick out the overall shape using white.

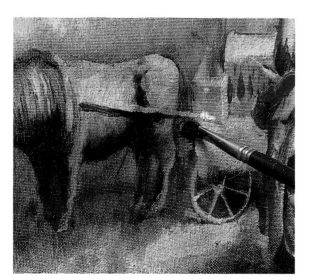

5.使用釉色來加強表面,同時控制明度。

5. Use a glaze to pick out the color of the subject while restraining the brightness.

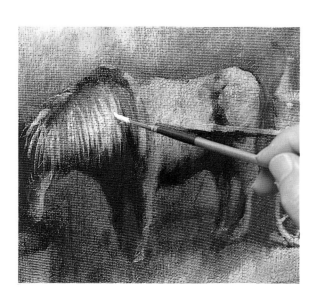

6.使用白色來加強鬃毛的層次感。

6. Go over the mane with white again to express the complicated flow of the mane.

使用外描輪廓來
表現動物的毛髮

當小動物在畫面裡扮演配件時，它們可在畫面裡被簡化或誇大以配合畫面。而要使動物生動的一秘訣在於毛髮及皮毛的輪廓表現。

Expressing the Texture of an Animal's Coat Through the Outline

When small animals are added to a picture in a secondary role, they may be simplified or exaggerated as necessary. The point to concentrate on to make them really come alive is the expression of the fur of their coat in the outline.

頭部及軀體應柔和的描繪。

The outline of the head or body should be drawn softly.

貓形飾品的輪廓要用堅硬的線條描繪。

The outline is drawn firmly to express a cat ornament.

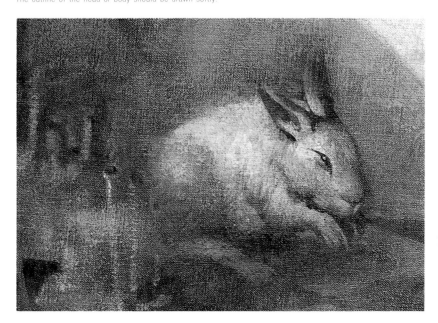

兔子，柔軟的筆觸用以描繪兔毛的柔軟。

A Rabbit. A soft line is used for the outline of the back to express the soft fur.

第四章
非物質的質感

Chapter 4
Non-physical Qualities

有些東西是實體無法形容的,當我們看一樣東西時,不僅是看它的外形,也包括了過去對此物的記憶及感覺。如果我們曾因玻璃而受過傷,則將來對玻璃的感覺會有所不同。不論將來有任何新材料發明,臘像館的臘像永遠無法和真人一樣。

生命的感覺和物體的外形是完全不同的。光線經時間變化而改變,而我們的記憶也是一樣的。在本章中我將解釋如何表現此抽象的質感。

There are some qualities that are impossible to express physically. When we look at an object we see more than its physical appearance and our past memories and experiences effect the way we feel about it. If we injure ourselves on some glass, this will effect the way we see glass in the future. Again, no matter what marvelous new materials are invented, the figures in a waxworks museum will never look alive. The feeling of life belongs to a different category to appearance. Light alters with the passing of time and so do our memories. In this chapter, I will explain how to express this transient quality through painting.

光
Light

1.用白色來描繪牆壁的部份，並等顏料乾透。

1. Build up the areas of the walls where the light falls using white and allow it to dry.

2.調勻焦黃色的顏料，以及銀白色和釉料樹脂溶劑於小盤中，然後再平抹於畫布上。

2. Mix Burnt Sienna, Silver White and Damar varnish in a small dish then placing the canvas horizontally, pour it onto the surface.

3.將報紙平鋪在畫布上，有吸收多餘顏料的功用。

3. Place some newspaper over the picture to soak up the excess paint and adjust the shading.

4.待顏料完全乾燥之後再進行下一個部驟。

4. Allow the paint plenty of time to dry before moving on to the next process.

晨曦

清晨時打開閣樓的一扇窗，讓這城市的活力立刻隨著早晨的微風吹入窗內。一起去捕捉早晨的聲音及味道吧！

Morning Light

When we open an attic window, the energy of the freshly-awoken city floods into the room on the morning breeze. Let us try to capture these sounds and smells together with the morning light.

5.用砂紙摩擦圖畫畫面，然後繼續表現加強窗內外的明暗對比。

5. Rub down the surface of the picture with sandpaper then continue painting to bring out the contrast between the darkened interior of the room and the bright light outside.

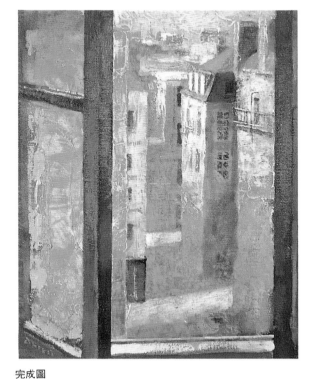

完成圖

The completed Picture.

夕照

一天結束時天空中殘留的光線以及初亮的燈光映在水面上
且永遠存在留於畫面上。

Twilight

The remaining light in the sky at the end of the
day and the electric lights which are just coming on
are reflected in the water and captured in a picture
for ever.

1.將溶劑及砂塗抹於畫面上以製造牆壁的效果。

1. Mix Gesso and sand then apply over the whole
surface of the canvas to create a texture like that
of wall.

2.將溶劑擠在雲彩的部份，色澤較明亮的地方。

2. Squeeze the Gesso out onto the areas where the bright clouds will be
positioned.

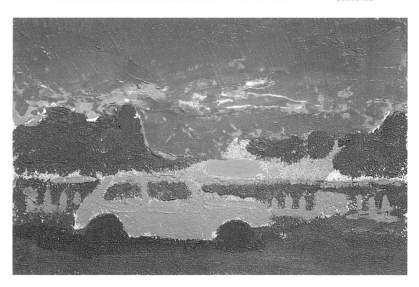

3.先畫日落的紅色，再畫城鎮的黑色。
　待其乾了之後，再畫天空。

3. Apply the red of the sunset and the dark colors
of the town then once these have dried, apply the
color of the sky over them.

4.使用砂紙磨掉多餘的彩料。

4. Use sandpaper to rub down the white of the Gesso.

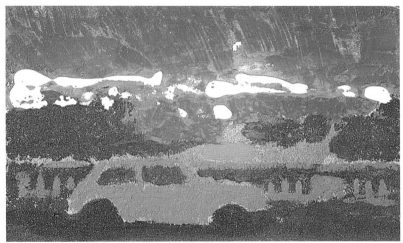

5.近照細部圖。

5. A close up of the area that has been rubbed down.

完成圖

The Completed Picture

記憶的質感
The Texture of Memory

1.以焦黃色爲底色，然後用以褐色加強建築及牆壁以及河邊的牆。

1. Apply a base color of Burnt Sienna then use white and Raw Umber to build up the buildings and the wall by the river over it.

2.將溶劑倒於河流上，再撒上砂粒使其看來更加眞實。

2. Pour some Alkyd painting medium over the surface of the picture then sprinkle some sand over it.

3.將畫置於平面上一至二日待其乾燥。

3. Place the picture on a horizontal surface and leave it for one to two days in order to dry.

畫面剝落不僅使畫面和諧，且能產生懷舊的感覺，似乎是在看一幅老壁畫一樣，這也許和人們的記憶有些許相似之處。

The effect of peeling of the paint does not only draw a picture together, it also creates a feeling of the passage of time, calling to mind an old mural. This is probably due to the fact that people's memories gradually peel away in much the same way.

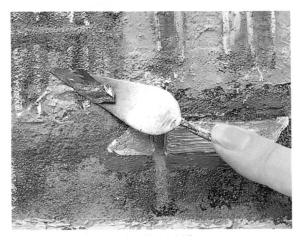

4.用畫刀將油彩剝落。

4. After the painting has progressed, use a sharp knife to peel off the paint.

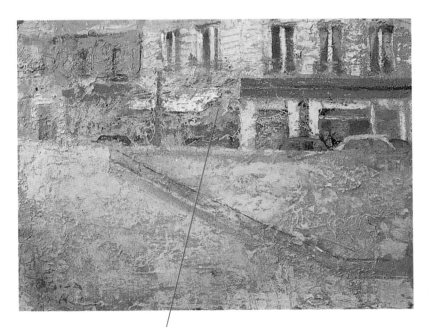

5.完成圖

The Finished Picture

剝除部份近照

A Close-up of the Peeling

人物
People

當我們畫人物時，應讓他們看起來逼真。畫人物有許多種技法，但我們在此介紹的是流漆的方式，讓畫面生動起來。

When we paint people, we want to give them a sense of life. There are various techniques for painting people, but here we utilize the run of the paint to bring the picture to life.

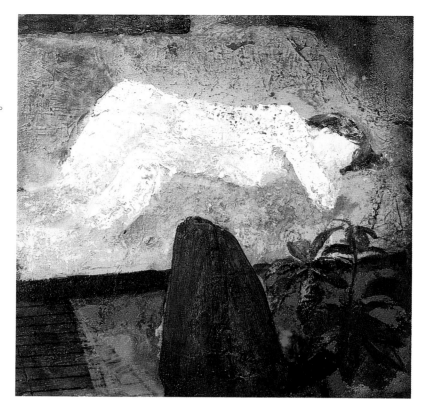

1.沙發上的裸像以白色處理。畫面的顏料厚度能創造實質感。

1. Paint the nude on the sofa using only white paint. A sense of volume is achieved through the thickness of the paint.

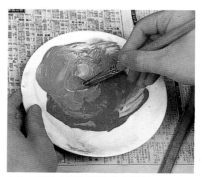

2.在小容器中調勻藍及白色顏料，然後加入稀釋油料。

2. Mix Cerulean Blue and White in a mixing dish then dilute with an adequate quantity of thinning oil.

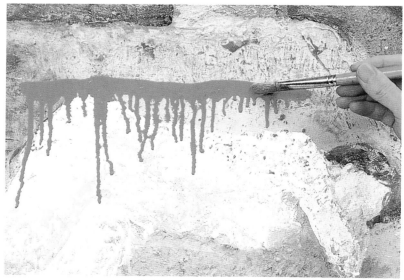

3.用筆沾起大量的顏料，然後畫一條橫向水平的線。讓顏料自然流下。

3. Pick up a lot of paint on the brush then draw a horizontal line across the canvas, allowing the paint to run down.

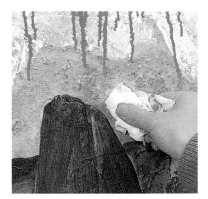

4.將不需流下顏料之處擦掉。

4. Wipe off the runs that appear where they are not required.

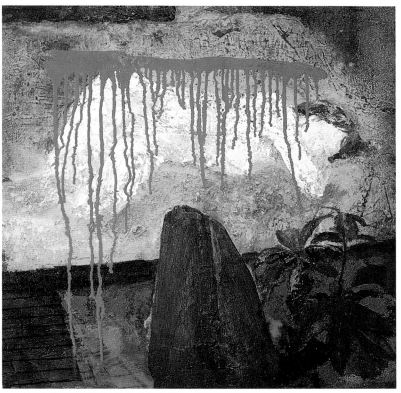

5.一旦顏料流下的程度足夠畫面構成所需,則將畫布平放使其乾燥。

5. Once the paint has run sufficiently, place the canvas horizontally and allow it to dry.

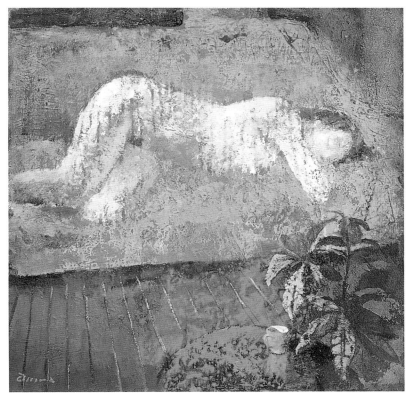

6.完成圖。顏料流下部份已被其他畫筆觸蓋過。
但它們的效果仍然會給觀衆帶來視覺效果。

The completed picture. The runs have been mostly painted over, but their effect still works on the viewer's subconscious.

天空
Sky

表現天空時，雖然在有限的畫布上作畫，但卻要表現出無限的空間來。在此例中，畫布的質地被用來表現一道道相間的暖冷色調，而且還可創造空間無限的感覺。

When expressing the sky, it is important to create an impression of its vastness even though you are working on a small canvas. In this example, the texture of the canvas has been utilized to produce alternate bands of warm and cold colors to create a complicated expression that hints at infinite spaces.

1.天空的底色是白色加上暖色調。森林的深色調和其附近房屋及陸地應成對比。

1. The base color for the sky at sunset is a gradation of white with a small amount of a warm color added. The dark of the forest should be contrasted with the bright areas of land and houses.

2.以褐粉紅色及其它暖色調上光。

2. Apply a coat of glaze created by mixing Brown Pink and a warm color.

3.再畫上一層冷色調（藍及白色），且以乾刷法上加強效果

3. Build up a coat of a cold color (Cerulean Blue and White) using dry brush technique.

步驟３之局部圖。冷色及暖色成明顯的對比。

A detail of the step 3. A strong contrast has been created between the warm and cold colors.

完成圖之局部圖。

一層赭紅色的釉使得湖水看來更加輕鬆。

A Detail of the Finished Picture. A glaze of Crimson Lake has been used to create a relaxed tonality.

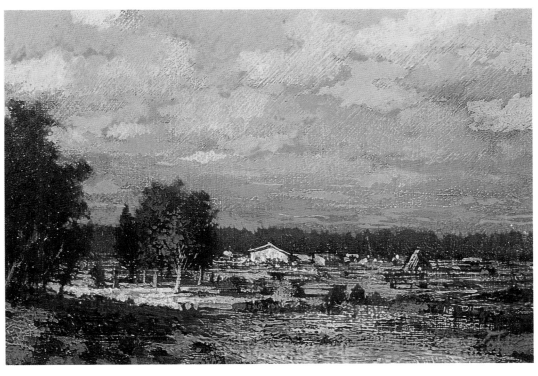

完成圖

The finished picture

色彩的控制

In order to achieve the tones you desire, it is best to start painting using bright colors. Even though you are working on a picture that expresses a feeling of sunset, it may look like a bright sunlit view in its early stages. The tones you desire can be achieved at the end through the use of glazing.

爲了要達到你所想要的色彩，要在開始作畫時，以明亮的顏色作畫。雖然你所要畫的是日落的景象，但在剛開始作畫時可能看來像是日光充足的景象。你所想達成的景象應在上釉後可以達成。

1.經多層上色後及上釉後之完成圖。

1. A picture that has been achieved through the build up of painting and glazing. The colors are much brighter than the original image.

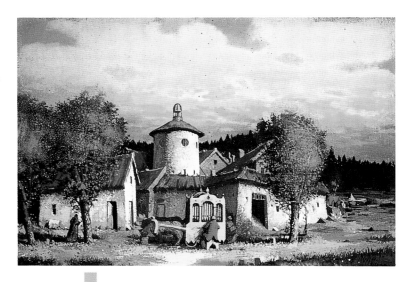

原來的顏色亮多了。

2.經過上赭紅釉之後的效果看來像日落時分的感覺。

2. A glaze of Crimson Lake creates the tones of sunset.

第五章
表現與技法問答

Chapter 5
Expression and Technique
Q & A

上美術課時我的老師指導我應注意質感及背景的不同。但我應如何分辨各種質感呢？

唯一的答案是：將你看到的表現出來，你無法表現你看不到且感覺不到的東西，但你練習後越多，則你看到比感覺到的更多。你不應只重視顏色及形狀的不同，而應該試著在各物件中體會這些質感，如此才能在你的畫作中表現出來。

At art lessons I was told to differentiate between the texture of the subject and the background, but how much should I concentrate on expressing these textures?

The only answer to this is; "Express it as you see it." You cannot express things that you cannot see or feel but the more you practice, the more you will notice in a subject. You should not concentrate solely on differences of shape and color, but also on the texture. Once you can recognize all these things in a subject, it is up to you whether you decide to express them in your work.

在作畫時可否將某些部份的質感保留而不畫出？

物體如在遠處，則其質感無法觀察得到。在此情況下如果仍執意表現質感則有些牽強。你可以距離來決定。也可以只表現你感覺最強烈的質感。這不但對表現質感來說是正確的，而且對繪畫來說亦是如此。質感應只是繪畫的一部份，也許是構圖上重要的一部份，但不是全部。

Is it permissible to leave areas in which the texture is not expressed?

As objects move into the distance, it becomes difficult to see the details and the texture cannot be discerned. In a case like this it would be a mistake to try and express the texture regardless. It is not only a question of distance, you should only express those textures that strike you strongly when you look at the subject. This is not only true of texture, but is the object of painting. Texture should be thought of being only a part, if an important one, of the composition.

我認為底色是整部畫面感覺的重要決定因素，但有沒有一個顏色是可以適用所有的畫面及題材的？

還有，您是否能告訴我基本色調及底色調之不同。

很抱歉，油畫裡的特殊名稱每個人的叫法不同，但基本上底色是畫布第一個塗上的顏色，而基本色調僅是底色上所增加的顏色，可以增加其它顏料的效果。沒有任何一種顏色是可以適用於所有畫面的，十七、十八世紀的西班牙畫家習慣用極暗的色調當底色，但基本上中度色調的底色較適合一般人作畫。

I feel that the effect of the basic tone is altered by the color used but is there any color I could use which would work for every picture？ Also, could you tell me the difference between a basic tone and a toned ground?

Unfortunately the terms used in oil painting vary somewhat from person to person, but generally, a base tone is the one that is applied to the canvas first and white is usually used for this. A toned ground is the color that is applied over this to make the paints that are applied later even more effective. I am afraid that there is no color that can be used for every painting. The Spanish painters of the 17th and 18th centuries used a dark toned ground for their work, but generally a mid-tone makes it easier to achieve the coloring required.

每次我用釉料，它總無法被畫面上的顏料吸收，為什麼？

這是因為太多乾油料存在於畫中，而此乾油料會成這現象，叫作「油性飽和」，而此現象應在作畫的最後階段才會出現。為防止油性飽和的產生，應在調和顏料時降低亞麻油或罌粟油的比例。如果你希望上很多層釉，則不要在作畫時上太多層顏料。

Whenever I have tried glazing, I find that the glaze is repelled by the paint on the canvas. Why is this?

This is due to there being too much drying oil in the paint that is applied first and this repels the glaze. We refer to this condition as oil saturation and it should not become apparent until the picture is in its final stages. In order to prevent it from happening, the percentage of linseed or poppy oil in the lower coats of paint should be kept to a minimum. If you intend to apply several coats of glaze, you should avoid applying the paint too thickly.

我發覺如果我看照片則比較容易了解該物件的光線及形狀。先照相再從相片中觀察物件的作畫習慣好嗎？

你這樣作的原因可能是較容易觀察物件而不受到任何原有的想法影響。但是照片不能讓你正確的觀察深度及質感。而必須觀察實物才能得到這些訊息。如果你認為照片對你有益，那麼不要忘記照片裡的物件也必須要有真實感。

I find it easier to understand the light and shade of the subject when I see it in a photograph. Is there any problem in my photographing the subject first then working from the picture in this way?

The reason why you find it easier to work this way is because it allows you to study the colors without being led astray by preconceived ideas. However, a photograph does not always capture the feeling of depth or texture accurately and you have to study the actual subject in order to acquire this information. If you find it easier to work from a photograph, by all means do so, but you must not forget that what you really should express in your picture can only be obtained from real life.

每一家所作出的顏料色調均不一樣，是否有任何方法可以測量顏色？

即使同一個製造商所製造的顏料也會有顏色上的不同。印刷業有某些顏色上的標準，但油畫的顏料則無此標準。有許多顏料的名稱與其來源有關。例如那波里斯黃和喜恩那焦黃就是個例子。但即使是在喜恩那，土地的黃色也有許多不同的色調。唯一能決定顏色的方法是將顏料擠出以便觀察。但是最近有許多美術供應店禁止客人將顏料的蓋子打開。所以最好的方法是使用色度表來量測顏料，我本身使用四個不同廠商製造的褐色，但四種顏色都不同。

The tones of the colors vary between manufacturer but is there any standard by which colors can be measured?

Even colors by the same manufacturer vary according to when they were made. The printing industry has set standards for colors, but there is no standard for oil paints. The names of many of the colors refer to their place of origin, for instance, Naples Yellow or Burnt Sienna but even in Siena, the color of the earth varies depending on where it was excavated and again, the way it is burnt will also alter the tone. The only way to be really sure about a color is to look at it but recently, many art shops object to their customers opening the tubes of paint. As a result, one has no choice but to rely on color charts to gradually build up a collection of colors that you know you like. Personally, I use Raw Umber from four different manufacturers and each is an entirely different colors.

我發現我沒辦法等畫作的油漆完全乾燥，因此顏料經常混在一起，而產生泥濘般的效果。我看過快乾油，但我不知道要選哪一種，可否請你告訴我對於我這樣的初學者來說什麼較適合呢？

即使快乾油也無法在五分鐘之內完全乾透，它大約需一天或最快五個小時才能乾透，所以與其依賴這些材料，不如想想如何調整你作畫的方式。例如，當你要畫下厚厚一層油料來當白色底色時，如果你在一早畫底色，則第二天才能開始繼續作畫。但是如果白色底色在晚上塗上，則第二天一早則可以馬上開始作畫。釉料也可以如此上法，但是不需一次上太多。如果你小心的計劃，則不會將顏料混在一起。但是顏料如果只混進亞麻油，則需一星期左右才能乾透。如果你想趕快繼續作畫，則需使用快乾的材料。所有主要的材料商都需製快乾材料。如果使用，畫作可較快乾透。可用鹼性油料來塗較厚的顏料層，每一家廠商製造的顏色都有點不同，但你仍可放心使用，大概一天左右就會乾透。

I find it very difficult to wait for the paint to dry properly and as a result, the paints often mix with the lower ones and produce muddy results. I have seen fast-drying oils for sale, but there are so many different types that I do not know which to choose. Could you tell me if there is any type that would be suitable for a beginner like myself?

Even so-called fast-drying oils do not dry in five minutes, they take about one day or in the case of the very fast ones, five hours, so rather rely on these, it would be better if you thought about the way you work. For instance, let us consider a thick coat of white that has been applied as a base for glazing. If you apply the white first thing in the morning, you will not be able to do anymore to the picture until the following day, but if the white is applied just before you finish for the evening, it will be dry the following morning when you want to start work. The glaze should also be left to dry properly but it is not so critical as a thick layer of paint. If you plan your work carefully, you will find that the paints do not run into each other very often. However, plain white or paint that only has linseed oil mixed with it can take anything up to a week to dry and if you wish to continue work the following day, some kind of fast-drying medium is required. All the major material suppliers produce tubes of fast-drying medium and if these are used, a thick application of paint will dry much faster. If you want to apply a thin coat of paint, alkyd painting medium may be used to dilute the paint. Again, recently, several companies have started to produce fast-drying alkyd paints and although the tones are a little different, if this does not worry you, by all means go ahead and use them. These take about one day to dry.

結語

Afterword

　　對日本人來說，畫畫便等於表達情感。它們每一天的寫作是倚賴圖畫中的物件，而因爲此種倚賴性，他們很難體會物件的質感。他們認爲如果一個瓶子是瓶子，則一定會是玻璃作的，且不需在圖畫中表現此點。但油畫是經由西洋的實證主義所發展出來的。而對觀衆來說它非常的強烈。

　　這本書表現了質感的意義，質感不是作畫的全部，但確實在以往受到忽視。在此感謝武藏野美術大學的油田佐智子小姐，以及羽岡元先生（多摩美術大學）的協助。

　　（北條章）

To the Japanese, to draw a picture means to express a meaning. Their everyday writing relies on stylized pictures of objects and due to this standardized symbolism they find it difficult to come to terms with the idea of texture in a painting. They feel that if an object is in the shape of a bottle, it goes without saying that it is made of glass and there is no need to express this in the picture.
However, oil painting is a western discipline that was developed through European positivism and as a medium it is very strong materialistically. This book shows what is meant by texture from this point of view. Texture is not everything in an oil painting, but for a long time, it remained something that we did not pay sufficient attention to.
I would like to thank Ms. Sachiko Ikeda of the Musashino University of Art and Mr. Hajime Haneoka of Tama University of Art for their help in providing pictures for this book.

北條章

1953年　木縣生
1976　武藏野美術大學畢業
1978　武藏野美術大學研究所畢。'85年在武大擔任油畫研究室助敎。
1985　到法國。
1990　太平洋展，文部大臣獎。91年太平洋美術獎，92年阪本繁二郎獎。
現任太平洋美術會會友　武藏野美術學院油畫科講師。

Akira Hojo
1953 Born in Tochigi Prefecture.
1976 Graduated from Musashino University of Art
1978 Received a graduate degree from Musashino University of Art. He remained at the university until 1985 as an assistant in the oil painting department.
1985 Went to France.
1990 Exhibited in the Taiheiyo Exhibition and was received the Minister of Education Award.
1991 Received the Taiheiyo Art Award
1992 Received the Hanjiro Sakamoto Award
At present he is a member of the Taiheiyo Art Society and the chief lecturer in oil painting at the Musashino University of Art

鍋島正一

1955　兵庫縣生
1978　武藏野美術大學畢
1979　武藏野美術大學巴黎獎，隨即留法
1980　南法聖拉斐爾市國際展頭獎
1984　新制作協會展出品，89年、90年、92年新作家賞
1992　前田寬治大賞展，市民賞
現任　新製作協會會員，多摩美術大學講師

Masakazu Nabeshima
1955 Born in Hyogo Prefecture.
1978 Graduated from Musashino University of Art
1979 Received the Musashino University of Art Paris Award Grant and traveled to France.
1980 Received the Grand Prix at the San Raphael International Art Exhibition, South France.
1984 Exhibited in the Shinseisaku Kyokai Exhibition. Won the New Artist Award in 1989, 1990, 1992.
1992 Won the Citizen's Award at the Kanji Maeda Award Exhibition
At present he is a member of the Shinseisaku Kyokai and a lecturer at the Tama University of Art

名家序文摘要

名家創意 識別 包裝 海報 設計

北星圖書 新形象

震憾出版

名家創意識別設計

陳木村先生（中華民國形象研究發展協會理事長）

這是一本用不同手法編排、真正屬於CI的書，可以感受到此書能讓讀者用不同的立場，不同的方向去了解CI的內涵。

名家創意包裝設計

陳永基先生（陳永基設計工作室負責人）

「消費者第一次是買你的包裝，第二次才是買你的產品」，所以現階段行銷策略，廣告以至包裝設計，就成為決定買賣勝負的關鍵。

名家創意海報設計

柯鴻圖先生（台灣印象海報設計聯誼會會長）

國內出版商願意陸續編輯推廣，闡揚本土化作品，提昇海報的設計地位，個人自是樂觀其成，並予高度肯定。

北星信譽推薦・必備教學好書

日本美術學員的最佳教材

鉛筆畫技法

定價／350元

粉彩筆畫技法

定價／450元

沾水筆・彩色墨水技法

定價／450元

野外寫生技法

定價／400元

油畫質感表現技法

定價／450元

循序漸進的藝術學園：美術繪畫叢書

實用繪畫範本

定價／450元

粉彩畫技法

定價／450元

油畫基礎畫法

定價／450元

水彩技法圖解

定價／450元

最佳工具書

· 本書內容有標準大綱編字、基礎素
描構成、作品參考等三大類；並可
銜接平面設計課程，是從事美術、
設計類科學生最佳的工具書。
編著／葉田園　　定價／350元

精緻手繪POP叢書目錄

精緻手繪POP 廣告
精緻手繪POP叢書①
簡仁吉 編著
● 專為初學者設計之基礎書 ● 定價400元

精緻手繪POP變體字
精緻手繪POP叢書⑦
簡仁吉・簡志哲編著
● 實例示範POP變體字，實用的工具書 ● 定價400元

精緻手繪POP
精緻手繪POP叢書②
簡仁吉 編著
● 製作POP的最佳參考，提供精緻的海報製作範例 ● 定價400元

精緻創意POP字體
精緻手繪POP叢書⑧
簡仁吉・簡志哲編著
● 多種技巧的創意POP字體實例示範 ● 定價400元

精緻手繪POP字體
精緻手繪POP叢書③
簡仁吉 編著
● 最佳POP字體的工具書，讓您的POP字體呈多樣化 ● 定價400元

精緻創意POP插圖
精緻手繪POP叢書⑨
簡仁吉・吳銘書編著
● 各種技法綜合運用，必備的工具書 ● 定價400元

精緻手繪POP海報
精緻手繪POP叢書④
簡仁吉 編著
● 實例示範多種技巧的校園海報及商業海定 ● 定價400元

精緻手繪POP節慶篇
精緻手繪POP叢書⑩
簡仁吉・林東海編著
● 各季節之節慶海報實際範例及賣場規劃 ● 定價400元

精緻手繪POP展示
精緻手繪POP叢書⑤
簡仁吉 編著
● 各種賣場POP企劃及實景佈置 ● 定價400元

精緻手繪POP個性字
精緻手繪POP叢書⑪
簡仁吉・張麗琦編著
● 個性字書寫技法解說及實例示範 ● 定價400元

精緻手繪POP應用
精緻手繪POP叢書⑥
簡仁吉 編著
● 介紹各種場合POP的實際應用 ● 定價400元

精緻手繪POP校園篇
精緻手繪POP叢書⑫
林東海・張麗琦編著
● 改變學校形象，建立校園特色的最佳範本 ● 定價400元

新形象出版圖書目錄

郵撥：0510716-5　陳偉賢　　TEL:9207133・9278446　　FAX:9290713　　地址：北縣中和市中和路322號8Ｆ之1

一、美術設計

代碼	書名	編著者	定價
1-01	新插畫百科(上)	新形象	400
1-02	新插畫百科(下)	新形象	400
1-03	平面海報設計專集	新形象	400
1-05	藝術・設計的平面構成	新形象	380
1-06	世界名家插畫專集	新形象	600
1-07	包裝結構設計		400
1-08	現代商品包裝設計	鄧成連	400
1-09	世界名家兒童插畫專集	新形象	650
1-10	商業美術設計(平面應用篇)	陳孝銘	450
1-11	廣告視覺媒體設計	謝蘭芬	400
1-15	應用美術・設計	新形象	400
1-16	插畫藝術設計	新形象	400
1-18	基礎造形	陳寬祐	400
1-19	產品與工業設計(1)	吳志誠	600
1-20	產品與工業設計(2)	吳志誠	600
1-21	商業電腦繪圖設計	吳志誠	500
1-22	商標造形創作	新形象	350
1-23	插圖彙編(事物篇)	新形象	380
1-24	插圖彙編(交通工具篇)	新形象	380
1-25	插圖彙編(人物篇)	新形象	380

二、POP廣告設計

代碼	書名	編著者	定價
2-01	精緻手繪POP廣告1	簡仁吉等	400
2-02	精緻手繪POP2	簡仁吉	400
2-03	精緻手繪POP字體3	簡仁吉	400
2-04	精緻手繪POP海報4	簡仁吉	400
2-05	精緻手繪POP展示5	簡仁吉	400
2-06	精緻手繪POP應用6	簡仁吉	400
2-07	精緻手繪POP變體字7	簡志哲等	400
2-08	精緻創意POP字體8	張麗琦等	400
2-09	精緻創意POP插圖9	吳銘書等	400
2-10	精緻手繪POP畫典10	葉辰智等	400
2-11	精緻手繪POP個性字11	張麗琦等	400
2-12	精緻手繪POP校園篇12	林東海等	400
2-16	手繪POP的理論與實務	劉中興等	400

三、圖學、美術史

代碼	書名	編著者	定價
4-01	綜合圖學	王鍊登	250
4-02	製圖與議圖	李寬和	280
4-03	簡新透視圖學	廖有燦	300
4-04	基本透視實務技法	山城義彥	300
4-05	世界名家透視圖全集	新形象	600
4-06	西洋美術史(彩色版)	新形象	300
4-07	名家的藝術思想	新形象	400

四、色彩配色

代碼	書名	編著者	定價
5-01	色彩計劃	賴一輝	350
5-02	色彩與配色(附原版色票)	新形象	750
5-03	色彩與配色(彩色普級版)	新形象	300

五、室內設計

代碼	書名	編著者	定價
3-01	室內設計用語彙編	周重彥	200
3-02	商店設計	郭敏俊	480
3-03	名家室內設計作品專集	新形象	600
3-04	室內設計製圖實務與圖例(精)	彭維冠	650
3-05	室內設計製圖	宋玉眞	400
3-06	室內設計基本製圖	陳德貴	350
3-07	美國最新室內透視圖表現法1	羅啓敏	500
3-13	精緻室內設計	新形象	800
3-14	室內設計製圖實務(平)	彭維冠	450
3-15	商店透視・麥克筆技法	小掠勇記夫	500
3-16	室內外空間透視表現法	許正孝	480
3-17	現代室內設計全集	新形象	400
3-18	室內設計配色手冊	新形象	350
3-19	商店與餐廳室內透視	新形象	600
3-20	櫥窗設計與空間處理	新形象	1200
8-21	休閒俱樂部・酒吧與舞台設計	新形象	1200
3-22	室內空間設計	新形象	500
3-23	櫥窗設計與空間處理(平)	新形象	450
3-24	博物館＆休閒公園展示設計	新形象	800
3-25	個性化室內設計精華	新形象	500
3-26	室內設計＆空間運用	新形象	1000
3-27	萬國博覽會＆展示會	新形象	1200
3-28	中西傢俱的淵源和探討	謝蘭芬	300

六、SP行銷・企業識別設計

代碼	書名	編著者	定價
6-01	企業識別設計	東海・麗琦	450
6-02	商業名片設計(一)	林東海等	450
6-03	商業名片設計(二)	張麗琦等	450
6-04	名家創意系列①識別設計	新形象	1200

七、造園景觀

代碼	書名	編著者	定價
7-01	造園景觀設計	新形象	1200
7-02	現代都市街道景觀設計	新形象	1200
7-03	都市水景設計之要素與概念	新形象	1200
7-04	都市造景設計原理及整體概念	新形象	1200
7-05	最新歐洲建築設計	石金城	1500

八、廣告設計、企劃

代碼	書名	編著者	定價
9-02	CI與展示	吳江山	400
9-04	商標與CI	新形象	400
9-05	CI視覺設計(信封名片設計)	李天來	400
9-06	CI視覺設計(DM廣告型錄)(1)	李天來	450
9-07	CI視覺設計(包裝點線面)(1)	李天來	450
9-08	CI視覺設計(DM廣告型錄)(2)	李天來	450
9-09	CI視覺設計(企業名片吊卡廣告)	李天來	450
9-10	CI視覺設計(月曆PR設計)	李天來	450
9-11	美工設計完稿技法	新形象	450
9-12	商業廣告印刷設計	陳穎彬	450
9-13	包裝設計點線面	新形象	450
9-14	平面廣告設計與編排	新形象	450
9-15	CI戰略實務	陳木村	
9-16	被造忘的心形象	陳木村	150
9-17	CI經營實務	陳木村	280
9-18	綜藝形象100序	陳木村	

九、繪畫技法

代碼	書名	編著者	定價
8-01	基礎石膏素描	陳嘉仁	380
8-02	石膏素描技法專集	新形象	450
8-03	繪畫思想與造型理論	朴先圭	350
8-04	魏斯水彩畫專集	新形象	650
8-05	水彩靜物圖解	林振洋	380
8-06	油彩畫技法1	新形象	450
8-07	人物靜物的畫法2	新形象	450
8-08	風景表現技法3	新形象	450
8-09	石膏素描表現技法4	新形象	450
8-10	水彩・粉彩表現技法5	新形象	450
8-11	描繪技法6	葉田園	350
8-12	粉彩表現技法7	新形象	400
8-13	繪畫表現技法8	新形象	500
8-14	色鉛筆描繪技法9	新形象	400
8-15	油畫配色精要10	新形象	400
8-16	鉛筆技法11	新形象	350
8-17	基礎油畫12	新形象	450
8-18	世界名家水彩(1)	新形象	650
8-19	世界水彩作品專集(2)	新形象	650
8-20	名家水彩作品專集(3)	新形象	650
8-21	世界名家水彩作品專集(4)	新形象	650
8-22	世界名家水彩作品專集(5)	新形象	650
8-23	壓克力畫技法	楊恩生	400
8-24	不透明水彩技法	楊恩生	400
8-25	新素描技法解說	新形象	350
8-26	畫鳥・話鳥	新形象	450
8-27	噴畫技法	新形象	550
8-28	藝用解剖學	新形象	350
8-30	彩色墨水畫技法	劉興治	400
8-31	中國畫技法	陳永浩	450
8-32	千嬌百態	新形象	450
8-33	世界名家油畫專集	新形象	650
8-34	插畫技法	劉芷芸等	450
8-35	實用繪畫範本	新形象	400
8-36	粉彩技法	新形象	400
8-37	油畫基礎畫	新形象	400

十、建築、房地產

代碼	書名	編著者	定價
10-06	美國房地產買賣投資	解時村	220
10-16	建築設計的表現	新形象	500
10-20	寫實建築表現技法	濱脇普作	400

十一、工藝

代碼	書名	編著者	定價
11-01	工藝概論	王銘顯	240
11-02	籐編工藝	龐玉華	240
11-03	皮雕技法的基礎與應用	蘇雅汾	450
11-04	皮雕藝術技法	新形象	400
11-05	工藝鑑賞	鐘義明	480
11-06	小石頭的動物世界	新形象	350
11-07	陶藝娃娃	新形象	280
11-08	木彫技法	新形象	300
11-18	DIY①—美勞篇	新形象	450
11-19	談紙神工	紀勝傑	450
11-20	DIY②-工藝篇	新形象	450
11-21	DIY③-風格篇	新形象	450
11-22	DIY④-綜合媒材篇	新形象	450
11-23	DIY⑤-札貨篇	新形象	450
11-24	DIY⑥-巧飾篇	新形象	450
11-26	織布風雲	新形象	400
11-27	鐵的代誌	新形象	400
11-31	機械主義	新形象	400

十二、幼教叢書

代碼	書名	編著者	定價
12-02	最新兒童繪畫指導	陳穎彬	400
12-03	童話圖案集	新形象	350
12-04	教室環境設計	新形象	350
12-05	教具製作與應用	新形象	350

十三、攝影

代碼	書名	編著者	定價
13-01	世界名家攝影專集(1)	新形象	650
13-02	繪之影	曾崇詠	420
13-03	世界自然花卉	新形象	400

十四、字體設計

代碼	書名	編著者	定價
14-01	阿拉伯數字設計專集	新形象	200
14-02	中國文字造形設計	新形象	250
14-03	英文字體造形設計	陳穎彬	350

十五、服裝設計

代碼	書名	編著者	定價
15-01	蕭本龍服裝畫(1)	蕭本龍	400
15-02	蕭本龍服裝畫(2)	蕭本龍	500
15-03	蕭本龍服裝畫(3)	蕭本龍	500
15-04	世界傑出服裝畫家作品展	蕭本龍	400
15-05	名家服裝畫專集1	新形象	650
15-06	名家服裝畫專集2	新形象	650
15-07	基礎服裝畫	蔣愛華	350

十六、中國美術

代碼	書名	編著者	定價
16-01	中國名畫珍藏本		1000
16-02	沒落的行業一木刻專輯	楊國斌	400
16-03	大陸美術學院素描選	凡谷	350
16-04	大陸版畫新作選	新形象	350
16-05	陳永浩彩墨畫集	陳永浩	650

十七、其他

代碼	書名	定價
X0001	印刷設計圖案(人物篇)	380
X0002	印刷設計圖案(動物篇)	380
X0003	圖案設計(花木篇)	350
X0004	佐膝邦雄(動物描繪設計)	450
X0005	精細插畫設計	550
X0006	透明水彩表現技法	450
X0007	建築空間與景觀透視表現	500
X0008	最新噴畫技法	500
X0009	精緻手繪POP插圖(1)	300
X0010	精緻手繪POP插圖(2)	250
X0011	精細動物插畫設計	450
X0012	海報編輯設計	450
X0013	創意海報設計	450
X0014	實用海報設計	450
X0015	裝飾花邊圖案集成	380
X0016	實用聖誕圖案集成	380

油畫質感表現技法

定價：450元

出 版 者：新形象出版事業有限公司
負 責 人：陳偉賢
地　　址：台北縣中和市中和路322號8Ｆ之1
門　　市：北星圖書事業股份有限公司
　　　　　永和市中正路498號
電　　話：9229000（代表）　ＦＡＸ：9229041

原　　著：北條章・鍋島正一
編 譯 者：新形象出版公司編輯部
發 行 人：顏義勇
總 策 劃：陳偉昭

總 代 理：北星圖書事業股份有限公司
地　　址：台北縣永和市中正路462號5F
電　　話：9229000（代表）　ＦＡＸ：9229041
郵　　撥：0544500-7北星圖書帳戶
印 刷 所：彩藝印刷股份有限公司

行政院新聞局出版事業登記證／局版台業字第3928號
經濟部公司執／76建三辛字第21473號

國家圖書館出版品預行編目資料

油畫質感表現技法：Introduction to
expressing textures in oil painting／北
條章，鋼島正一原著；新形象出版公司編輯部
編譯. — 臺北縣中和市：新形象，1997[民
86]
　　面；　公分
ISBN 957-9679-03-7(精裝)

1.油畫

948.5　　　　　　　　　　　　　　　85012866